Pattern Sourcebook:
Nature 2
250 Patterns for Projects and Designs

Shigeki Nakamura

BEVERLY MASSACHUSETTS

ROCKPORT PUBLISHERS

First published in the United States of America by
Rockport Publishers, a member of
Quayside Publishing Group
100 Cummings Center
Suite 406-L
Beverly, Massachusetts 01915-6101
Telephone: (978) 282-9590
Fax: (978) 283-2742
www.rockpub.com

ISBN-13: 978-1-59253-559-0
ISBN-10: 1-59253-559-3

10 9 8 7 6 5 4 3 2 1

Translation: Lloyd Walker (R.I.C. Publications)

Printed in Singapore

Preface

The phrase "flowers, birds, wind, and moon" [*Kacho fugetsu*] is the embodiment of the Japanese sense of natural beauty. Handed down, along with "snow, moon, and flower" [*Yuki tsuki hana*], through the ages in popular lore as an elegant aestheticism that indulges in views of beautiful nature, neither of the words in the phrase "flowers, birds, wind, and moon" taken separately would detract from their inherent allure.

This book, *Pattern Sourcebook: Nature 2, 250 Patterns for Projects and Designs*, is comprised of the following four chapters.

● Flowers—The patterns and combinations of seasonal flowers.
● Birds—Flowers associated with birds. Birds often used in patterns.
● Wind—Scenery, staffage, customs, and other patterns that establish an atmosphere.
● Moon—Expressions, in pattern, of the diverse emotions induced by the moon.

Each character in the phrase "flowers, birds, wind and moon" seems to play the leading role, or each leading role seems to stand out when observed in separate chapters featuring the traditional patterns represented by each name. However, inseparable scenes, the inevitability of combination, the motifs indispensable to the conveyance of shrewd messages, etc. seem to overlap, intersect, and echo together across each chapter, overflowing with sensitivity impossible to express fully in a single word. The allure of these four chapters lies not only in the observation of concise pattern categories, but also in the rebirth of the reader's realization of a depth of expression in the phrase "flowers, birds, wind and moon" that is so typically Japanese.

Of the motifs representative of the "flowers, birds, wind, and moon" in traditional patterns, the chrysanthemum [*kiku*] and the peony [*botan*] are most prevalent among flowers, and the crane [*tsuru*] most prevalent among birds, yet the designs do not display the same breadth of variety found in modern motifs. The pattern names are also often duplicated. However, we continue to insatiately draw these limited motifs, endlessly modifying them to create bright, healthy, and kaleidoscopic patterns. Comparing these variations of form, we get a sense of the flexibility and the spirit of the designs created by our forebears and come to understand that it is not the rarity of the motif but its expression that draws us to its pattern.

It is my hope that you, the reader, will use these diverse examples of traditional patterns as your design base, and in so doing, contribute to the evolution of the brilliant world of design developed by our predecessors.

Shigeki Nakamura (Cobble Collaboration)

Contents

How to Use This Book

Materials in the designs have been extracted from the existing traditional cloud and wave patterns in order to focus on the main points specified in the text of this book. Our main aim is to present the patterns in a way that the structure of the design can be used for development. Consequently, we have modified many of the cloud and wave patterns and special features of the patterns to present them with our own original layout and coloring. Although the designs are based on the traditional designs, they are not the designs shown in their original form. The files on the CD-ROM are, in principle, complete unit samples, but the images used as materials in the book have been trimmed to fit the layout and the colors have been partially modified in some cases. Also, some of the complete data has been re-sized to fit the content of the CD-ROM.

Page Layout

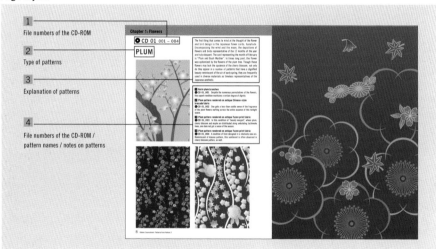

The attached CD-ROM is a hybrid type that can be used with Macintosh or Windows operating systems. The recorded contents are identical whichever system is used. In the supplementary CD-ROM there are 250 samples of pattern materials recorded in both JPEG and PSD image formats. In order to use the designs it is necessary to use the applications (for example, Adobe Photoshop) in order to open the recorded image files. For additional precautions on usage, you must read "readme" on the CD-ROM.

Chapter 1
Flowers
CD 01:001-091

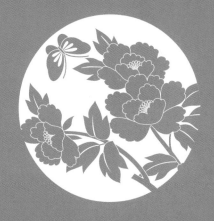

● CD 01 001 – 004

PLUM

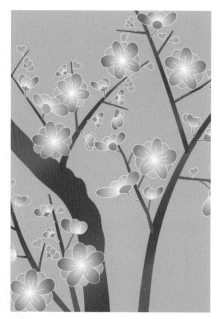

The first thing that comes to mind at the thought of the flower and bird design is the Japanese flower cards, hanafuda. Encompassing the wind and the moon, the depictions of flowers and birds representative of the 12 months of the year are truly eloquent. The card representing the month of February is "Plum and Bush Warbler". In times long past, the flower was epitomized by the flowers of the plum tree. Though these flowers may lack the opulence of the cherry blossom, not only do they appear in a number of patterns that have a dignified beauty reminiscent of the air of early spring, they are frequently used in diverse materials as timeless representatives of the Japanese aesthetic.

1 **Korin plum branches**
●**CD 01_001** Despite the numerous permutations of the flowers, this superb rendition maintains a certain degree of dignity.

2 **Plum pattern rendered on antique Chinese-style brocade fabric**
●**CD 01_002** One gets a less-than-subtle sense of the fragrance of the plum flowers wafting across the entire expanse of this twilight space.

3 **Plum pattern rendered on antique Yuzen print fabric**
●**CD 01_003** In this rendition of "beauty merged", where plum, cherry blossom and maple are distributed along undulating tachiwaku lines, one does not get a sense of the season.

4 **Plum pattern rendered on antique Yuzen print fabric**
●**CD 01_004** A rendition of form designed in a relatively new era. Reminiscent of kimono pattern, this sentiment is often observed in cherry blossom patters, as well.

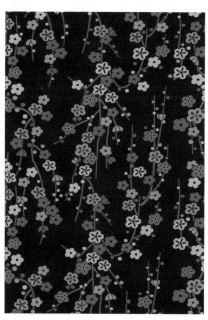

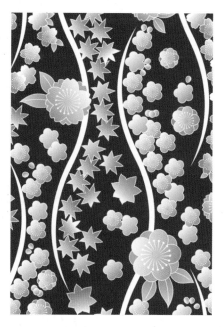

● CD 01 005 – 008

CHERRY BLOSSOMS-1

Whether masterpiece or run-of-the-mill, the variety of works of traditional patterns using the cherry blossom is truly diverse. In this section, the more ubiquitous masterpieces have been avoided to provide a selection collected from a somewhat different perspective. A comparison of the works presented in other sections will certainly impart a sense of the enthusiasm of those who developed these cherry blossom patterns with a conceptual freedom that never once strays from traditional methods.

1 Cherry blossom pattern rendered on antique Yuzen print fabric
● CD 01_005 Somewhat reminiscent of gadgetry, the diverse cherry blossom patterns expressed here give this rendition an endearing finish.

2 Cherry blossoms rendered on an embroidered long-sleeved kimono
● CD 01_006 Though the lines in this expression of embroidery in design are slightly imperfect, the imperfection may have been incorporated intentionally to make this piece more interesting.

3 Falling cherry blossom pattern rendered on antique Yuzen print fabric
● CD 01_007 Viewed at night, these cherry blossoms seem to have been designed to resemble the stars. Contrary to the conventional cherry blossom pattern, this work demonstrates the floridity of shadow.

4 Bound flowers rendered on antique Yuzen print fabric
● CD 01_008 A rendition of form designed in a relatively new era. Reminiscent of kimono pattern, this sentiment is often observed in cherry blossom patters, as well.

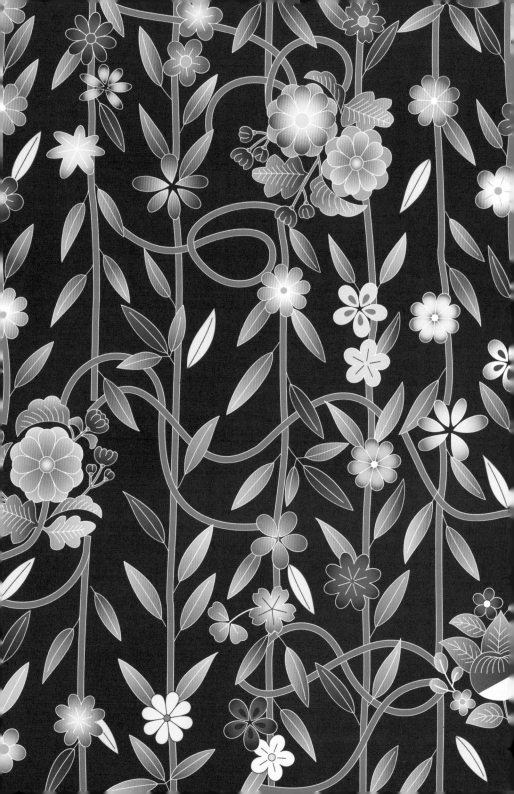

● CD 01 009 – 012

CHERRY BLOSSOMS-2

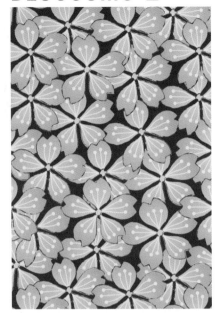

1 Falling cherry blossom pattern rendered on a *Maki-e* comb
●CD 01_009 The densely lain falling cherry blossoms form a woven pattern. An expression that is not often found among the diverse cherry blossom patterns, this is an example of superior design.

2 Cherry blossom pattern rendered on antique short-sleeved kimono fabric
●CD 01_010 Mixed with dappled cloth, this rendition assumes an easy affinity devoid of planarity.

3 Scattered cherry blossom pattern rendered on antique embroidered fabric
●CD 01_011 The temporally variant hues of the fallen cherry blossoms strike an air of stately dignity.

4 Striped scattered cherry blossom pattern rendered on antique embroidered fabric
●CD 01_012 A rendition of cherry blossoms of diverse sizes and shapes. A luxuriant rendition of temporal transition and spatial expansion coupled with the diversity of the cherry blossom.

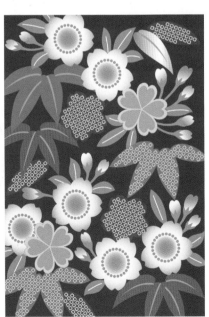

● CD 01 013 – 016
PEONY-1

Consensus is divided as to whether to consider the blossoms of these excessively large flowers opulent or garish. While the peony observed in traditional patterns retain a certain controlled dignity, by no means do they lack a sense of beauty that one wishes his eyes to bask in from time to time, nor are they inferior in form. This dichotomy of opinion can perhaps be attributed simply to personal preference. Therein lays the appeal of the peony.

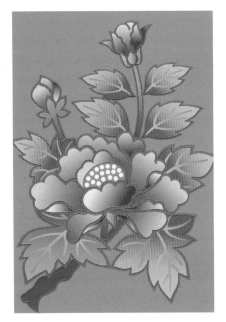

1 Peony pattern rendered on a antique twill fabric
● CD 01_013 Rendered in the form of a modern crest, this is a study of the fundamentals of graphic representation of the peony.

2 Peony rendered on indigo blue cotton fabric
● CD 01_014 Peony rendered among lion hair arabesque. The flowing curvature of their lines has an implausible charm.

3 Peony on an ancient bronze mirror
● CD 01_015 This rendition of form, the marriage of sophisticated peony and vine strikes an air of controlled majesty.

4 Peony and butterfly pattern rendered on antique Chinese-style brocade fabric
● CD 01_016 Though rendered on antique fabric, the fresh use of color suppresses one's sense of the weight of the peony.

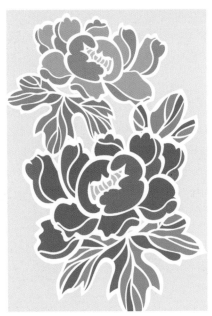

● CD 01 017 – 020
PEONY-2

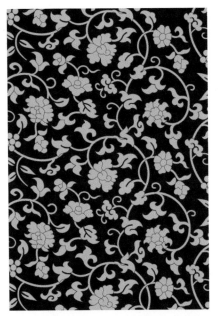

1 Peony arabesque rendered on Higashiyama gold brocade
● CD 01_017 An example of antique fabric. Here, the vines are reduplicated in this Kodaiji Temple gold brocade rendition of peony arabesque.

2 Peony arabesque rendered on antique short-sleeved kimono fabric
● CD 01_018 Despite its similarity to item No. 01_017, the lack of stateliness can be attributed to the epochal and practical differences.

3 Peony arabesque rendered in pattern stitching
● CD 01_019 Pattern stitching is but one of the diverse methods of embroidery. In this rendition, the designer attempts to contrast the solidity of the peony (rendered in step-stitch) and the lines of the peony when using pattern stitching.

4 Peony pattern rendered on antique Yuzen print fabric
● CD 01_020 Following the example of the chrysanthemum, this rendition of large peony flowers is both brilliant and bold.

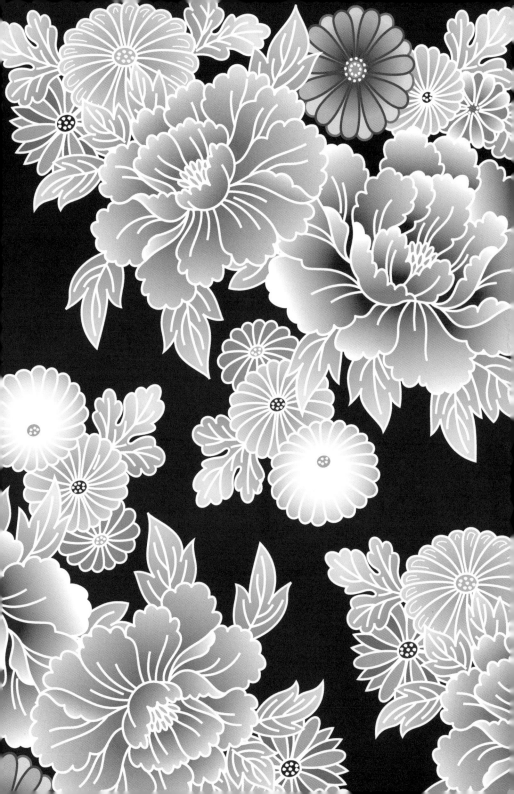

● CD 01 021 – 024

SPRING FLOWERS

Spring – the season of multitudes of blooming flowers. In traditional patterns, however, one is struck by the limited selection of flowers represented. Though the western flowers of today may not have existed then, by no means were the flowers of the past few. It is only natural, perhaps, that the esthetic held to by those who selected the flowers most suited to their purpose and the sentiment of those who desired their creations in the past should differ from that of today. Even so, it is unfortunate that among the flower patterns that anyone would consider charming there are so few examples that can be considered superior.

1 Mallow rose pattern rendered on a Maki-e lacquered multi-tiered box
●CD 01_02 Easily likened to a beautiful woman, this rendition uses colored lacquer to create a different kind of beauty.

2 Mallow rose pattern rendered in Nabeshima over glaze
●CD 01_022 An elegant mallow rose pattern rendered in the unique lines of colored Nabeshima (porcelain). The colors are in transition.

3 Kerrias (Japanese rose) pattern rendered on antique fabric
●CD 01_02 A preferably simplified rendition of a cluster of Japanese rose. The pigmentation is close to that of actual Japanese rose.

4 Spring flower pattern rendered on Antique Yuzen print fabric
● CD 01_024 A gathering of cherry blossoms, wisteria, Chinese peony root and gymnaster savatieri rendered with an opulence typical of Yuzen.

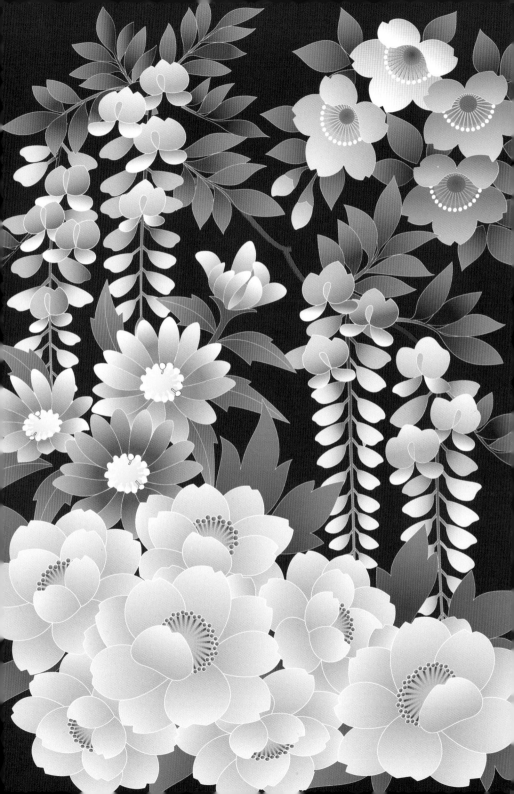

● CD 01 025 – 026

PAULOWNIA

Though in *hanafuda* December is the month attributed to the paulownia, this flower is classified here in spring, the season in which it blooms. The paulownia crest today is used by the prime minister of Japan. Known as the auspicious bird's roosting tree, and once the imperial crest, this highly dignified pattern was been handed down from the royal household to the samurai warrior class. Though also known sometimes as the "57-flowered paulownia" and at other times the "53-flowered paulownia" for its varying patterns of 57 and 53 flowers, as a traditional pattern the paulownia crest need not elicit from the observer excessive nervousness.

1 Paulownia rendered on Kyokarakami paper
● CD 01_025 This rendition makes use of the 57-flowered paulownia, suggesting that it had probably been created for some noble household.

2 Paulownia rendered on Antique Chinese-style brocade fabric
● CD 01_026 A brilliant example of a work that loses none of its repose, despite the use of rich colors.

⬤ CD 01 027 – 030
CLEMATIS

Named *Tessenka* (directly translated as "steel wire flower"), or Clematis, for the inherent steel-like strength of its vines, designs infused with a sense of vitality are more suited to renditions of the clematis that those that depict densely formed flowers. This could account for its ubiquitous use in arabesque design. Due to its relatively unique yet recent introduction to Japan, it often exudes an air far different from what one may consider typically Japanese.

1 Clematis in stencil-dyed rendition
⬤ **CD 01_027** An arabesque pattern rendered in its most basic form, this pattern can be utilized even if the flowers depicted here are substituted for others.

2 Clematis rendered in Chinese-style brocade
⬤ **CD 01_028** A slightly older style of rendition of the form of the flower. The Chinese-style brocade pattern is an example of basic form that shares characteristics with other types of patterns (such as lion hair arabesque).

3 Clematis rendered in Chinese-style brocade
⬤ **CD 01_029** A fine example worthy of the distinction of the arabesque pattern, as long as the flowers and leaves that are central to this rendition are preserved.

4 Clematis rendered on an embroidered foil-fabric sash
⬤ **CD 01_030** Typically a staple of the Noh costume, embroidered foil cloth is the marriage of embroidery and impressed gold (or silver) foil on traditional Japanese fabric that offers a dignified opulence akin to Chinese-style brocade.

● CD 01 031 – 034
SUMMER GRASSES-1

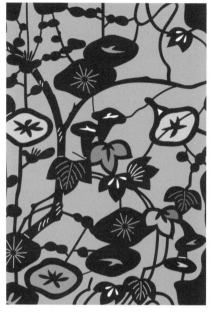

As evident in the references made to *tsuyuwake-goromo*, the kimono worn when walking through wet summer grasses (Manyoshu, Volume 10), and the grasses and flowers that seem to grow back with ever greater vitality no matter how much they are cut (Manyoshu, Volume 11), the term "Summer Grasses" has referred to the grasses and flowers of summer since the Manyo Era. The humid, wet climate of the Japanese summer is the ideal environment for grasses and flowers, and in concert with the vine plants that fill the senses with brilliant hues, powerful scents and life itself, the emotional aspect of the detail of these patterns seem to hide even the shadows.

1 Morning glory pattern rendered on under glaze paper stencil
● CD 01_031 Familiar and highly free-form, this form of technique is applicable to any rendition.

2 Morning glory pattern rendered on an embroidered foil-fabric Noh wig sash
● CD 01_032 The Noh wig sash is a brow band tied over the wig of the female persona in Noh. This narrow sash is decorated with majestic patterns.

3 Morning glory rendered on an impressed gold foil short-sleeved kimono
● CD 01_033 Though a stately pattern flecked with foil, remove the foil and we a left with a pretty morning glory pattern.

4 Arrowhead arabesque rendered on a lacquered tray
● CD 01_034 Similar in form to a dart, arrowhead is a water plant also known as "General Grass" or "Victory Grass." Its shape is figurative.

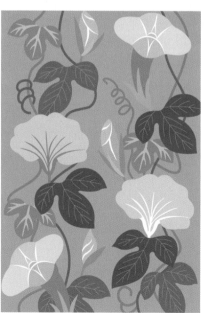

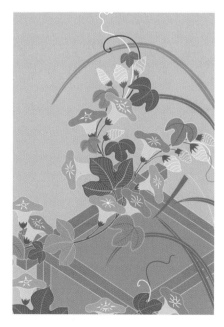

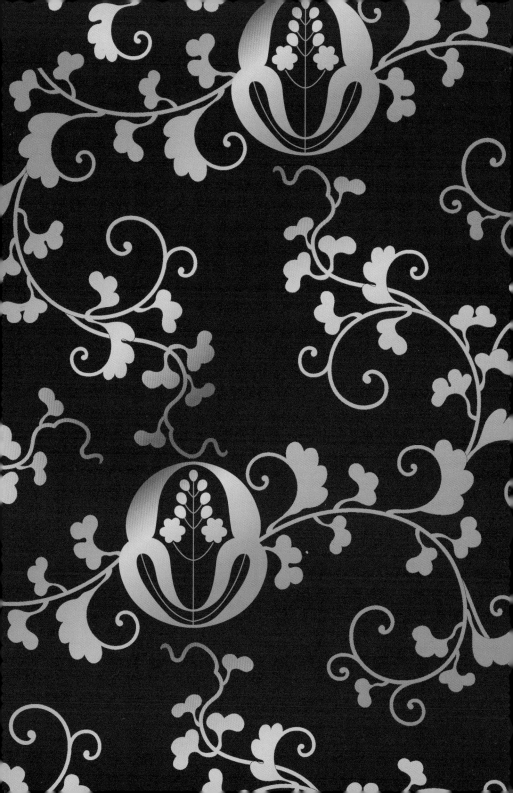

● CD 01 035 – 038
SUMMER GRASSES-2

1 A Chinese lantern pattern rendered on illustrated earthenware
● **CD 01_035** Though hardly a superior pattern, this design has been chosen for the untutored use of brushed gold paint and its uniqueness.

2 An artichoke pattern rendered on a short-sleeved *Yuzen* print fan
● **CD 01_036** This artichoke pattern is also a relatively rare design. The conciseness of its design is due in part to having been drawn on only one part of this *Yuzen* pattern.

3 Grape arabesque rendered on under glaze paper stencil
● **CD 01_037** In terms of its emotional aspect, this rendition perhaps lacks a certain degree of harmony in its somewhat clumsy expression.

4 A grape pattern rendered on Antique *Yuzen* print fabric
● **CD 01_038** A brilliant grape pattern of beautifully rendered leaves accented with fruit of slightly subdued hues.

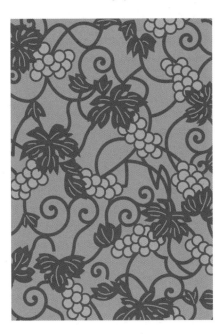

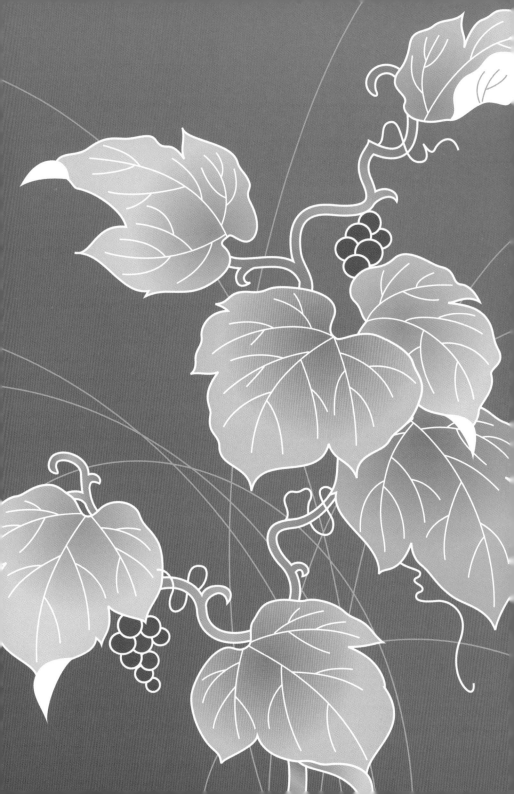

● CD 01 001 – 091
SUMMER GRASSES-3

1 A colored lacquer chloranthus serratus pattern
● CD 01_039 The era from whence this piece originates is unknown, and though a slightly graphic rendition, the dainty design may be worthy of greater attention.

2 A fringed orchid pattern rendered on a *Maki-e* lacquer letter box
● CD 01_040 A pattern as rare as that described on 039. Owing perhaps to its lack of a sense of weight, the daintiness depicted here would probably not have been preferred by the ancients.

3 A hydrangea pattern rendered on an Akashiyaki water pitcher
● CD 01_041 Akashiyaki is a style of ceramics developed in the latter half of the Edo era. Influenced perhaps by the illustrated ceramics of Kyoyaki and other styles, the hues employed by Akashiyaki are vibrant.

4 A hydrangea pattern rendered on antique *Yuzen* print fabric
● CD 01_042 This piece is rendered with a refined tonality. Touched here and there with gold and silver, the petals impart have an antique and elegant air.

● CD 01 043 – 046
SUMMER GRASSES-4

1 Water iris rendered on a short-sleeved *Yuzen* print kimono
● **CD 01_043** The neatly rendered strokes form a beautiful pattern that tells of the passion the ancients held for the water iris and the iris.

2 A stencil-dyed rendition of hollyhock arabesque
● **CD 01_044** Unlike the hollyhock observed in *Yuzen* print or other kimono design, this rendition gives the observer the impression of a still image reminiscent of an armorial crest.

3 Lilies rendered on antique embroidered foil-fabric
● **CD 01_045** The lilies rendered here are somewhat bulky owing to the embroidered foil-fabric and its purpose (as a Noh costume).

4 A lily pattern rendered on antique Yuzen print fabric
● **CD 01_046** Though a highly graphic rendition, as a lily pattern, this gives off a stronger fragrance.

● CD 01 047 – 048
BOTTLE GOURD

Going by the three names of "hisago," "fukube," and "yugao," when referred to as a traditional, the bottle gourd is usually referred to as the "yugao pattern." The hourglass shape of the bottle gourd, frequently put to practical use as a container for water, wine, and ladles, is often rendered with a familiarity that is antithetical to stateliness and dignity.

1 **Bottle gourd rendered on a woven sash**
● CD 01_047 The solid, bizarre shapes of the bottle gourd provides an accent that prioritizes familiarity over sophistication.

2 **A bottle gourd pattern rendered in indigo blue dye**
● CD 01_048 The use of thick and thin lines lends rich contours to the monochromatic composition of distinctive bottle gourds.

● CD 01 049 – 052
CHRYSANTHEMUM-1

The chrysanthemum is not considered one of the seven autumn grasses. The chrysanthemum is, in a manner of speaking, a symbol of autumn that is in a class of its own. One reason is the magical attributes it is bathed in, a characteristic it does not share with the seven grasses (bush clover, bellflower, zebra grass, dianthus, patrinia, thoroughwort, kudzu). The knowledge imported from China that *kikusui*, water in which chrysanthemum blossoms have been immersed, is thought to be a potion of perpetual youth and longevity perhaps derives from an irreconcilability with the emotional aspect of the seven grasses. The chrysanthemum is used as staffage not only in this chapter, but in the bird, wind and moon chapters, as well. Try comparing one to the other.

1 A chrysanthemum pattern rendered on a square Imari plate ●CD 01_049 Though it mutates with the surface of the image, this rendition loses nothing of its delicate and graceful touch.

2 Chrysanthemum arabesque rendered in Chinese-style brocade ●CD 01_050 The chrysanthemum arabesque pattern on this Noh costume flows continually. The tips of the 16-petal chrysanthemum are oblate.

3 Chrysanthemum arabesque rendered on short-sleeved kimono fabric ●CD 01_051 The combination of the chrysanthemum and water. The 10-petaled monochromatic chrysanthemum was perhaps chosen because the artist decided to focus on the arabesque pattern that shatters tradition and the waveform.

4 Chrysanthemum arabesque rendered in indigo blue ● CD 01_052 Though the beauty of indigo blue dye is second to none, a little color was intentionally added.

● CD 01 053 – 056
CHRYSANTHEMUM-2

1 A chrysanthemum pattern on a *Maki-e* lacquered tray
● CD 01_053 Zebra grass and dew grass have been borrowed to add a tinge of the emotional aspect of autumn to the chrysanthemum.

2 A chrysanthemum pattern rendered on antique Chinese-style brocade fabric
● CD 01_054 The contrast of the bold lines of the lattice and two varieties of chrysanthemum that cover them is highly evocative of growth.

3 Chrysanthemum rendered on *Maki-e* lacquered furniture
● CD 01_055 One cannot help but feel driven to extract and develop these elaborately drawn chrysanthemum flowers and leaves.

4 Peony and chrysanthemum on antique *Yuzen* print fabric
● CD 01_056 A graceful and endearing design, interestingly depicting the decorated sleeves of a long-sleeved kimono as a pattern.

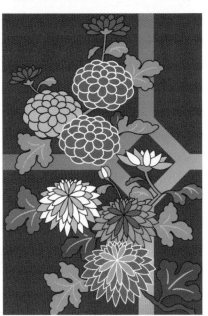

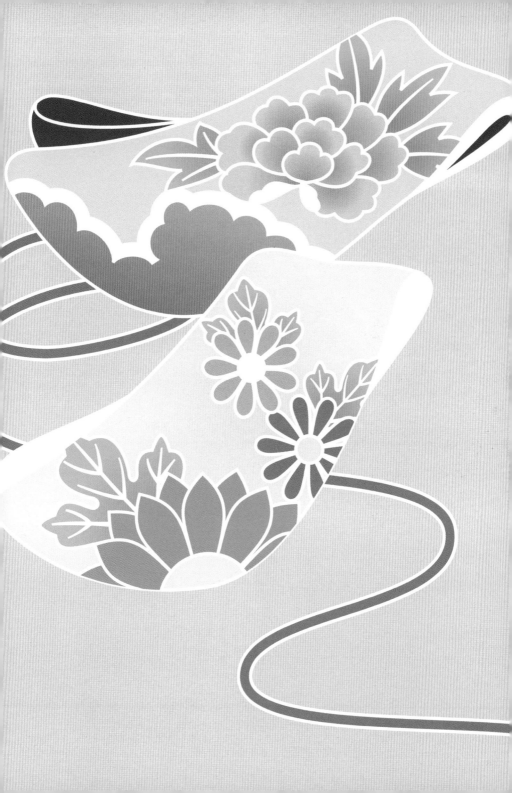

● CD 01 057 – 060

MAPLE

During the Manyo Era it was yellow-tinged leaves. No one knows for sure when red-tinged leaves came to represent the maple. Though the yellow leaves of the Gingko are figurative and beautiful in their hue, there is a sense that they concede to the maple. Furthermore, second only to the cherry blossom, the maple appears frequently among the *hyakunin isshu waka* poems, and when rendered in consort with the background images (Tatsutagawa, deer, etc.) depicted in the poems, the images evoked by the patterns unfold, eliciting an understanding of their picturesqueness and evincing empathy.

1 A maple pattern rendered on antique dyed fabric
● CD 01_057 Rendered as if mindful of the crunching sound of the footfall of deer, this pattern is a light and tasteful expression of multilayered leaves.

2 A maple pattern rendered on antique *Yuzen* print fabric
● CD 01_058 Purposely avoiding the use of red, this is a graceful rendition of gold and silver maple leaves.

3 A maple pattern rendered on antique *Yuzen* print fabric
● CD 01_059 The simply rendered veinless leaves, the light and shadow evoked using a limited selection of colors of a similar hue... the very sight of these beautiful maple leaves elicit from the observer a sigh.

4 A maple pattern rendered on antique *Bingata* stencil dyed fabric
● CD 01_060 Though the introduction of the blossoms of the plum tree seems to detract from the harmony of this pattern, it expresses the esthetic beauty of the four seasons of mountain hamlets in an old and often used method that brings together these seasonal flowers.

● CD 01 061 – 064
AUTUMN GRASSES-1

Patterns did not shed their Chinese influences to evolve into designs that were truly representative of the unique Japanese sentiment and visual perception until the latter half of the Heian Period. The autumn grass patterns are said to be the first to break the mold. Indeed, the names of the autumn grasses are woven into the prose of the *The Tale of Genji* in phrases such as *"Aki wa yo no hito no mezuru ominaeshi...saojika no tsuma ni sumeru hagi no tsuyu"* (The patrinia that is loved by all people in the autumn...the dew-covered bush clover that the male deer would wive), that sing of preferences and tastes in abundance. To be certain, the patterns of autumn grasses are omnipotent in their use as both the main characters and the incidental details in design.

1 Dianthus rendered on antique embroidered foil-fabric
● **CD 01_061** Surely it is the bulky embroidered foil fabric that detracts from the autumnal sentiment. One finds himself yearning to add more transparency to this design.

2 Tartarian aster rendered on antique embroidered foil-fabric ● **CD 01_062** Though as member of the chrysanthemum family, its leaves are light. The tartarian aster is often mixed with other autumn grasses in renditions of traditional patterns.

3 A hand-drawn rendition of bellflower on antique *Yuzen* print fabric ● **CD 01_063** In the original one can see the brush stroke. The grass at the bottom of the image is bush clover, not bellflower.

4 Autumn grasses on antique *Yuzen* print fabric
● **CD 01_064** An attraction derived from the figurative form of the rarely used Japanese hop (Humulus japonicus) as the central focus of this pattern.

● CD 01 065 – 068
AUTUMN
GRASSES-2

1 *Kumotori* bush clover rendered on antique *Yuzen* print fabric
● CD 01_065 This uncluttered pattern rendered in subdued hues is elegantly tasteful. This style of Kumotori composition is often used.

2 A contiguous bellflower and snakeroot pattern
● CD 01_066 A prototype rendering *Yuzen* print bellflower and *Maki-e* lacquer snakeroot on the same level.

3 Bellflower arabesque on *Maki-e* lacquered furniture
● CD 01_067 Similar to patterns 029 and 034, in this rendition, the blossoms of the bellflower are made the central focus of this trademark arabesque pattern.

4 An autumn grass pattern rendered on a multi-tiered box
● CD 01_068 This conglomeration of seasonal flowers offers a well-balanced charming design of flowers both large and small.

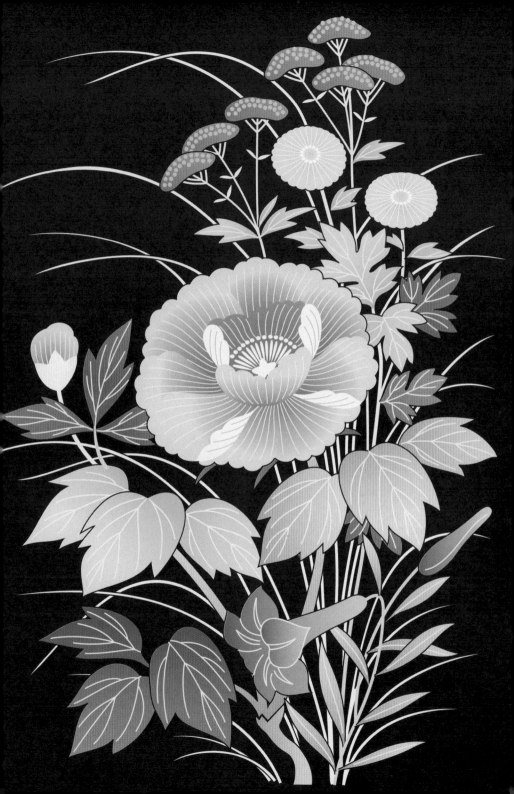

● CD 01 069 – 072
AUTUMN VIEWS-1

Unlike the patterns that stand aloof on the influence of their Chinese origins, these patterns have broadened their perspective to include the flowers of autumn fields. Appreciation of the "sensitivity of ephemera," the awareness of the transience of all things palpable in the easily overlooked grasses and flowers of autumn has given birth to numerous autumn grass patterns, and the esthetic sense of beauty held by the Japanese people has its origin in poetic verse.

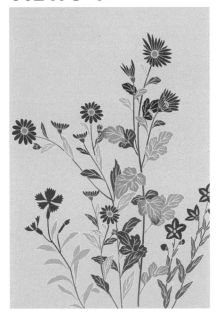

1 A hand-drawn autumn grass pattern rendered on antique *Yuzen* print fabric
● CD 01_069 There is a certain comforting gentleness in this somewhat negligent and clumsy rendition of wild chrysanthemum, bellflower and dianthus.

2 Pomegranate rendered in *Maki-e* lacquer
● CD 01_070 The slightly clumsy lines go well with the pomegranate design in this relatively rare pattern.

3 A stencil-dyed rendition of autumn grasses
● CD 01_071 With the exception of the barely visible surface of the ground, the autumn grasses are tightly arranged in a pattern that could only be rendered using autumn grasses.

4 An autumn grass pattern rendered on antique *Yuzen* print fabric
● CD 01_072 One gets a sense of the heart of the artist who is moved by the beauty of both withering and gracefully drooping flowers.

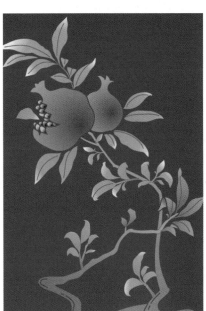

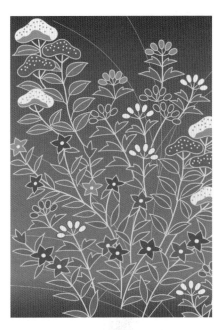

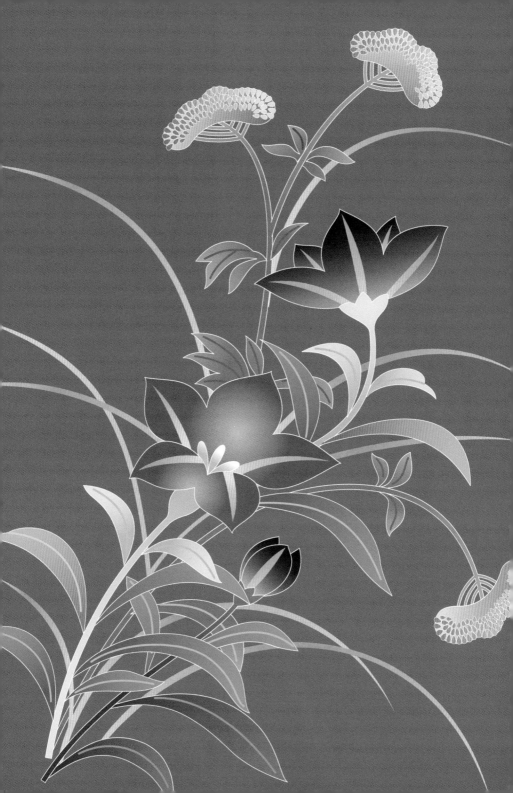

● CD 01 073 – 074
AUTUMN VIEWS-2

1 A rowel of autumn grasses rendered on antique *Yuzen* print fabric
● **CD 01_073** In the original, the bush clover and wild chrysanthemum are rendered in white outline. They are used as a back pattern so as to draw attention to the colorful autumn grasses.

2 A rowel of autumn grasses rendered on antique *Yuzen* print fabric
● **CD 01_074** A somewhat overwhelming rendition of autumn grasses. Though it is the observer's prerogative to decide whether it is pretty gaudy, this is an excellent example of a pattern created with the kimono consumer in mind.

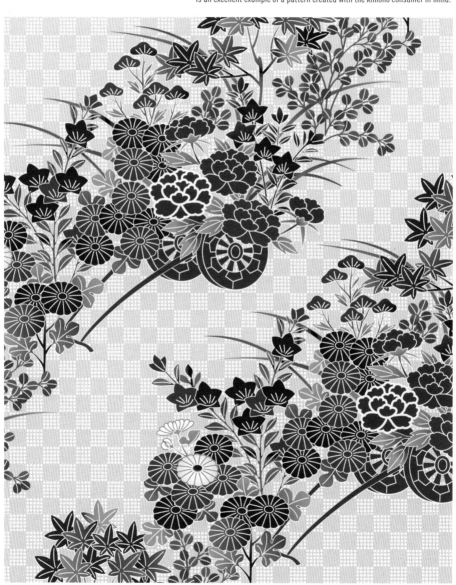

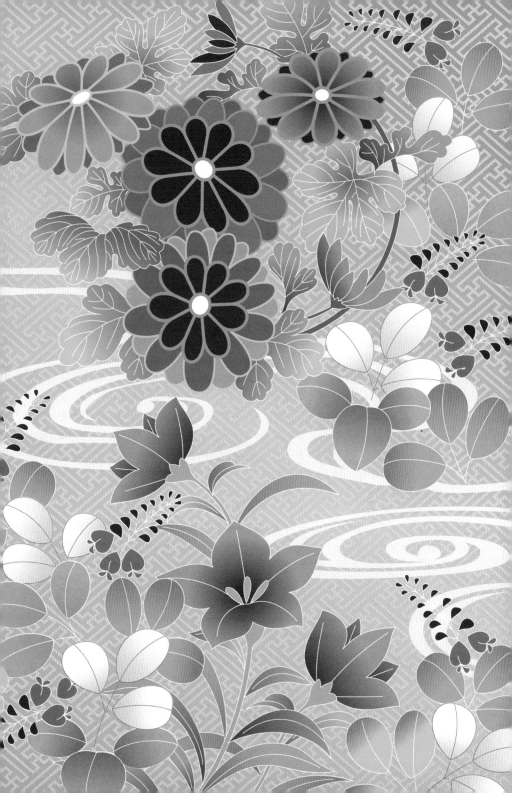

⬤ CD 01 075 – 078
CAMELLIA

The sensitivity of the Japanese people is recognizable in the kanji character written with the "tree" radical and the "spring" root. The camellia pattern originated in the Muromachi Period, and though it is said that these patterns had a slightly religious tint, they evolved with the advent of the Edo Period with little regard for their origins (fetish or otherwise). They were avoided most as family crests for samurai households.

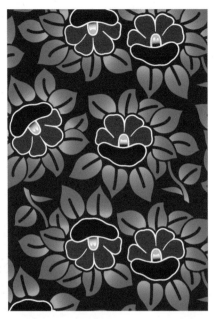

1 A camellia pattern rendered on antique stenciled *Yuzen* print fabric
⬤ CD 01_075 This repetitive pattern of a single branch of camellia is the epitome of the camellia blossoming under winter skies.

2 A camellia pattern rendered on antique *Yuzen* print fabric
⬤ CD 01_076 The blossoms seem to gradually loose their color as they separate from the picture book; or perhaps it is the other way around. Could they be suggestive of some kind of story?

3 Camellia rendered in *Urushi-e* lacquer
⬤ CD 01_077 The stereotypically rendered shape of the tree branch is traditional. One should take heed of the subtle curvature of the leaves and petals.

4 Camellia on *Maki-e* lacquered furniture
⬤ CD 01_078 The detail of the flowers and leaves observed close up make this an excellent example of design.

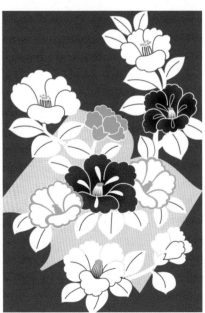

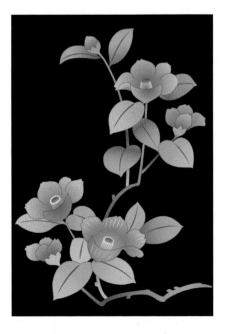

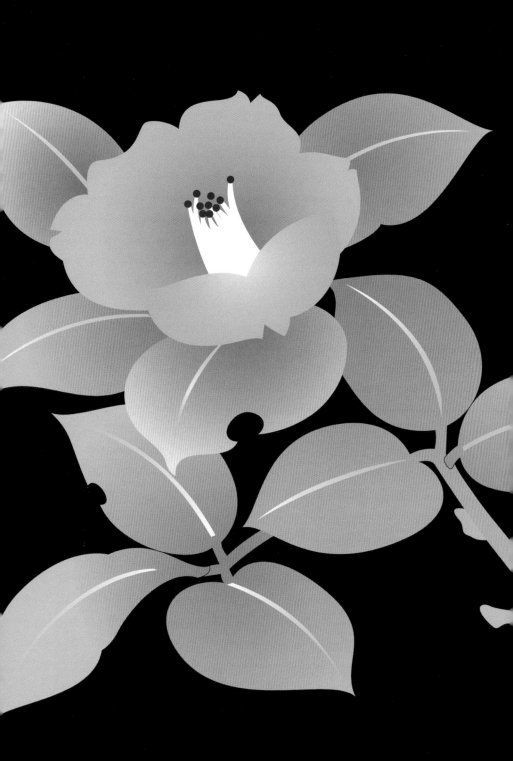

● CD 01 079 – 082

BAMBOO

Refreshing form and color and profound insight into design. A quick look through pattern materials will reveal numerous masterpieces among the bamboo patterns. This highly ubiquitous plant responds to an expansive range of designs, from the distinguished to the common, that are in no way unpleasant to the observer. For this reason, the bamboo is indispensable even today in purification ceremonies such as the Shinto ground-breaking ceremony and the *Tanabata* star festival.

1 Bamboo arabesque rendered on an embroidered wig sash
● CD 01_079 A vertically linked arabesque that imparts a sense of fresh gentleness and pure sultriness.

2 A bamboo pattern rendered on a transparent sword guard
● CD 01_080 Painted metal work. Called the spring of bamboo. For the bamboo, the autumn is spring. A simple and powerful bamboo pattern.

3 A *chumon* bamboo pattern rendered on a paper stencil
● CD 01_081 Ever changing form that can be considered the most basic form of the bamboo pattern.

4 A bamboo pattern rendered on a *Maki-e* lacquered letter box
● CD 01_082 A more sophisticated version of the bamboo pattern shown in item 081, this rendition has an atmosphere that is tranquil and chaste.

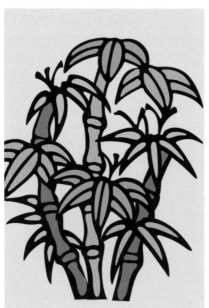

● CD 01 083 – 086
WINTER VIEWS

Refreshing form and color and profound insight into design. A quick look through pattern materials will reveal numerous masterpieces among the bamboo patterns. This highly ubiquitous plant responds to an expansive range of designs, from the distinguished to the common, that are in no way unpleasant to the observer. For this reason, the bamboo is indispensable even today in purification ceremonies such as the Shinto ground-breaking ceremony and the *Tanabata* star festival.

1 Bamboo on Chinese-style gold and silver thread brocade fabric
● **CD 01_083** The bamboo, grass and blossoms are rendered on bamboo leaves as if they vestiges of snow. The sparkling gold and silver no doubt resemble snow.

2 A snow-covered bamboo pattern rendered on antique *Yuzen* print fabric
● **CD 01_084** Coupled with the snow accumulating on the lower leaves and the ground, the rich colors of the bamboo leaves give the observer a sense of the life force of the bamboo. One wonders whether this example needs the snow to impart its message.

3 A daffodil pattern on a *kagikakushi* decorative nail cover rendered via the chasing method of carving
● **CD 01_085** The term "daffodil" is a seasonal phrase used to refer to winter. The image of the beauty of a daffodil basking in winter skies makes one feel the winter cold even more. Here, this mood has been transported indoors in a compact design.

4 Nandina on antique *Yuzen* print fabric
● **CD 01_086** The snow-covered Nandina is introduced in example 247 in the Moon chapter. Consider the two examples from a comparative perspective.

● CD 01 087 – 088
SEASONAL FLOWERS-1

Bringing together all of the seasonal flowers in one rendition is a method often employed in pattern design. This method is used when the designer wishes to give the observer a sense of the four seasons, to impress upon him the beauty inherent in all flowers. To do so, he avoids focusing on a particular season or flower, prioritizing beauty itself. Harmony is not disturbed because the plum and the maple are brought together. Indeed, this truth is even more obvious when the objects around us are depicted in the pattern.

1 Flowers in a haze on antique *Yuzen* print fabric
● CD 01_087 Camellia, bamboo grass, iris, maple, bush clover, arista, and spring mist. Does this feel the least bit discordant to you?

2 Gathered flowers rendered on antique *Yuzen* print fabric
● CD 01_088 A *komon* pattern of cherry blossoms, falling peony, cosmos, the asa-no-ha (hemp plant leaf) pattern of six identical diamonds arranged around a central point and *mujinagiku* ("badger" chrysanthemum). There is nothing discordant about this rendition.

● **CD 01** 089 – 090

SEASONAL FLOWERS-2

1 Illustrated booklets on antique *Yuzen* print fabric
● **CD 01_089** Plum, maple, chrysanthemum inside the illustrated booklet, and butterflies. The cherry blossom petal is most likely from a cherry tree existing elsewhere.

2 A bouquet pattern rendered on antique *Yuzen* print fabric
● **CD 01_090** Peony, chrysanthemum, bellflower and falling cherry blossoms, all superimposed with small mallets in a free-spirited and beautifully finished design.

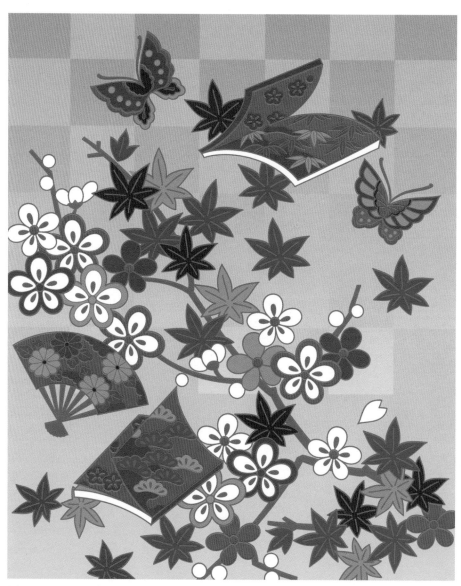

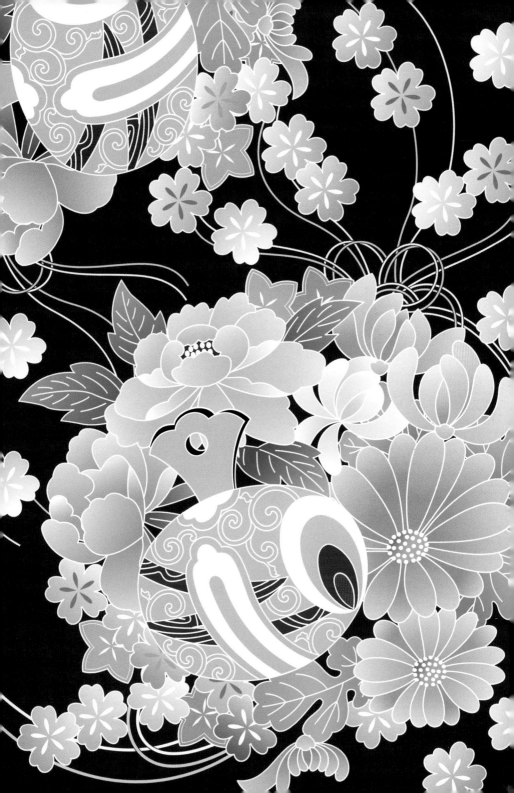

3 **Leaves and blossoms blown together on antique *Yuzen* print fabric**

○ **CD 01_091** Literally a pattern of blossoms and leaves strewn together, this is a convenient form of design. Since there is no need to limit oneself to flowers or leaves, a pattern can be rendered by bringing together a number of items. So prevalent is this form that it is found in the art of cuisine and sweet-making, as well. A so-called classic pattern.

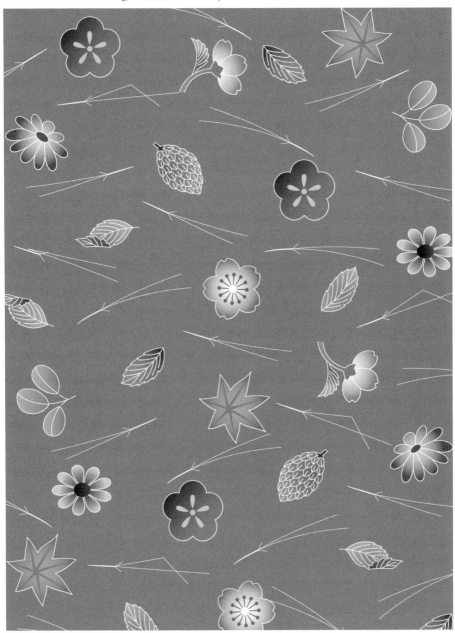

Chapter 2
Birds
CD 02:092-138

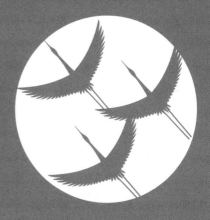

● CD 02 092 – 093

CRANES-1

Even before knowledge of the bird as a symbol of auspice was imported, the Japanese observer must surely have been held prisoner by the handsome form of the standing crane, surely he must have been enthralled at the grace of the bird in flight. For the modern observer, as well, there are numerous renditions of the crane among the Penglai patterns (pine, bamboo, rock, crane, tortoise combined in a delomorphous pattern), whether they be picturesque and realistic or simply evoke a sense of beauty. This is perhaps due to our pursuit of the beauty we envision in the image of the crane, one that is not influenced by the work as a cultural treasure or as an object of art.

1 **Cranes and pine rendered on antique** *Yuzen* **print fabric** ● **CD 02_092** This rendition of the bird in flight most resembles the crane. Not limited to *Yuzen* print, this pattern is observed in renditions created on diverse media.

2 **Cranes on an antique** *Yuzen* **print fabric fan** ● **CD 02_093** Cranes in flight from an overhead perspective. The cranes are exalted even as the view of the world below is entrapped in the form of the fans.

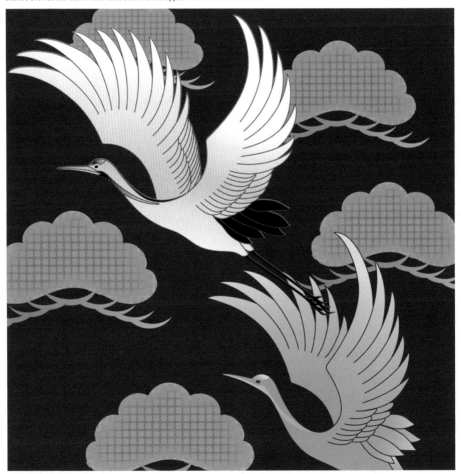

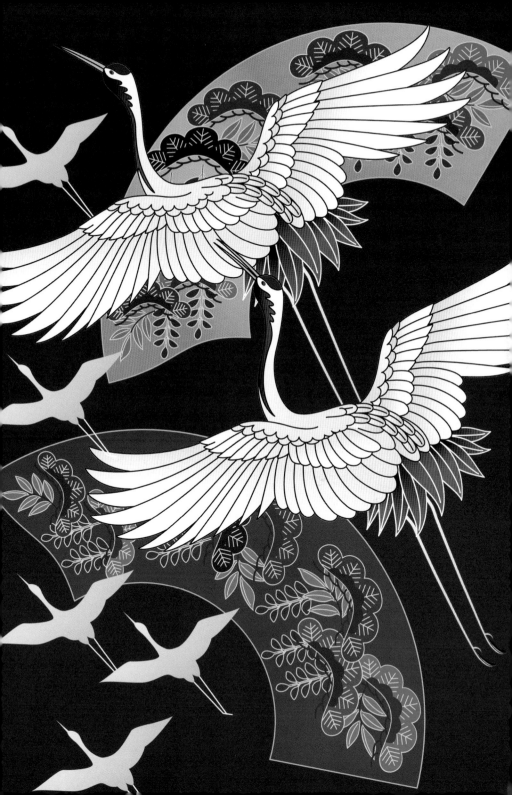

● CD 02 094 – 095
CRANES-2

1 **Waves and cranes rendered on antique *Yuzen* print fabric** ● CD 02_094 Cranes seeking prey among the turbulent waves. The somewhat dark hues aim to express the singularity of the crane in reality, not to render it in abstraction.
2 **Plum and cranes rendered on antique *Yuzen* print fabric** ● CD 02_095 This pattern resembles the cranes in item 092. It exudes a beauty that reveres the form of all birds in flight, not just the crane.

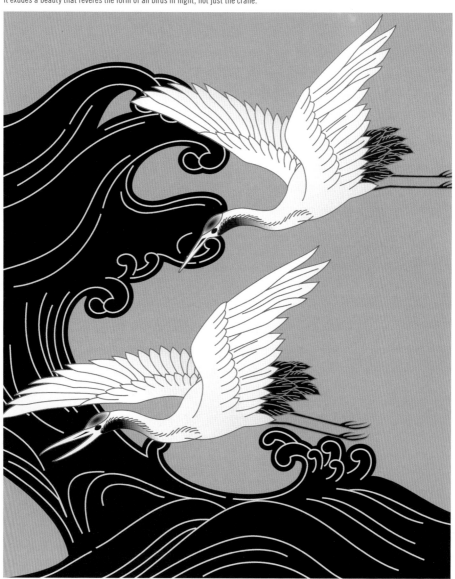

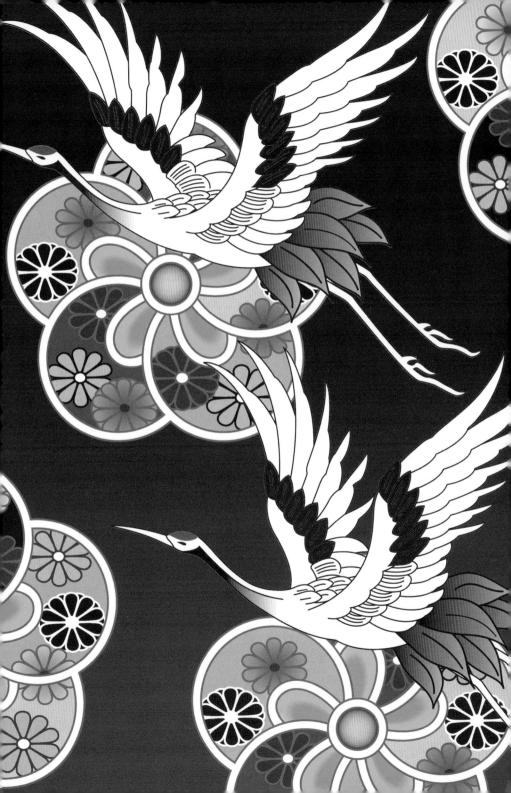

● CD 02 096 – 099
CRANES-3

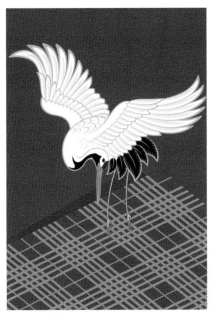

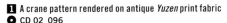

1 A crane pattern rendered on antique *Yuzen* print fabric
● CD 02_096
Items 096 and 097 are both renditions of the crane as prey. In these examples, diverse ideas that incorporate the movement of the crane are tested.

2 A crane pattern rendered on antique *Yuzen* print fabric
● CD 02_097
Though typological in its rendition of actual scenery in design, the artists attempt to camouflage the crane against its background makes this example appealing.

3 A crane pattern on stencil-dyed fabric
● CD 02_098
As with the delomorphous pine-eating cranes rendered in pine and crane patterns and the cranes rendered in Penglai patterns, the cranes depicted in items 098 and 099 also show no movement.

4 A rendition of chrysanthemum and cranes on gold brocade fabric
● CD 02_099
This is an example of the elegance of the crane even when rendered in staid delomorphous fashion. It is, likely, this elegance that prompted Japan Airlines to choose the crane as its corporate crest.

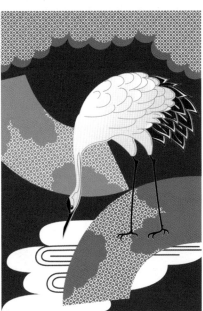

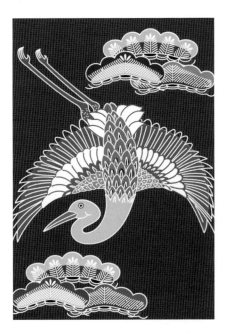

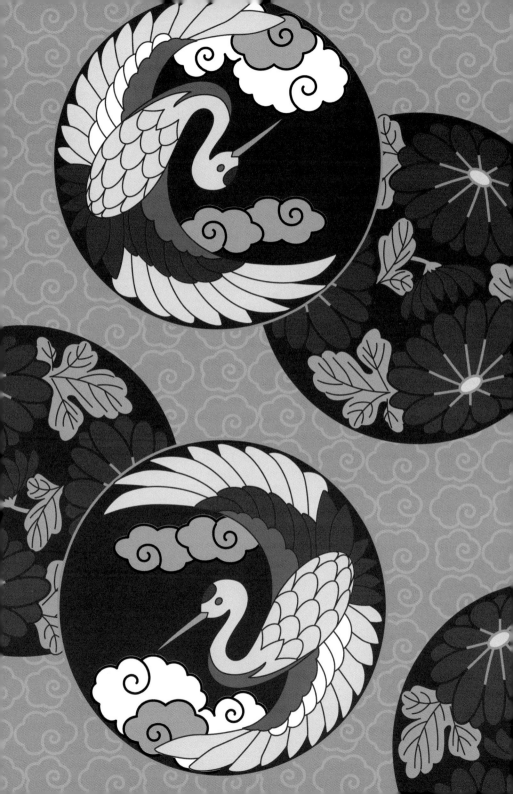

● CD 02 100 – 103
CRANES-4

The beauty of the crane can be attributed to the highly unique ability of the observer to superimpose his own image of the crane on the patterns he sees. Therefore, even if not picturesque, the crane's beauty is easily expressed. Indeed, it is the capacity for imagination aroused by each pattern that makes the crane beautiful. This is true of the cherry blossom pattern, as well, where superior design more than realism stimulates our sensitivities.

1 A crane against the sunrise rendered on illustrated ceramics
● **CD 02_100** In Eiraku Hozen's (1759-1854, Kyoto ware) famous "crane in the rising sun" pattern teacup, gold-painted waves are drawn directly below the crane. It is such a superior piece of work that even this epigone seems good.

2 A crane pattern rendered on antique embroidered fabric
● **CD 02_101** Flying crane evanescent in the blue vault of heaven. The uncontrived warmly curving lines are brilliant.

3 A woven crane background pattern on antique fabric
● **CD 02_102** Three types of flying cranes are superimposed in a contiguous design on the woven background pattern of pine leaves as if they, too, are part of the background weave. The observer need not get close to recognize the form of the cranes captured in the features of these birds.

4 Cranes in flight on a *Maki-e* lacquered inkstone case
● **CD 02_103** Designs such as this, where simplified renditions of cranes are shown in flight across space, are not rare. Their individual appeal lies in the spatial distribution and perspective of the cranes.

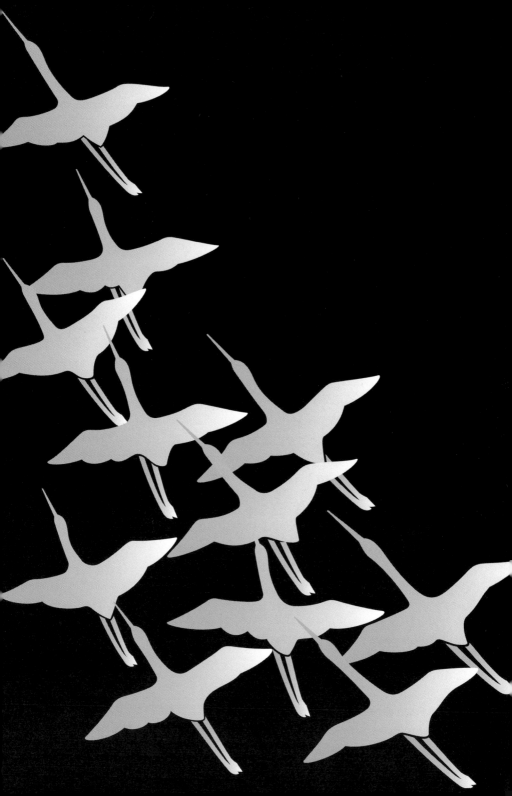

● CD 02 104 – 107
CRANES-5

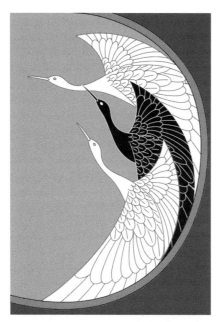

1 A crane pattern rendered on antique *Yuzen* print fabric
● CD 02_104 This crane pattern is somewhat rare. A radical form of perspective is employed to superimpose crane images on each other in this crestlike rendition.

2 Origami cranes rendered on antique *Yuzen* print fabric
● CD 02_105 The inimitable form of paper-crafted cranes rendered here as bright, charming designs.

3 A crane pattern rendered on dyed gold and silver washi paper
● CD 02_106 Cranes integrated in a staple form of Japanese design reminiscent of scattered colored paper to form a flock. This often observed design is superb in its evolvability.

4 A crane pattern on short-sleeved *Yuzen* print kimono fabric
● CD 02_107 This technique of impressing komon patterns on the body of the birds is also a traditional method, but its success is dependent on the subject. This is a beautiful and elegant design.

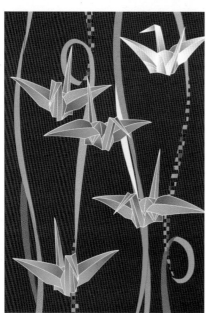

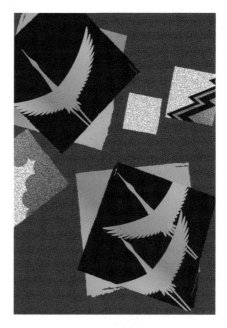

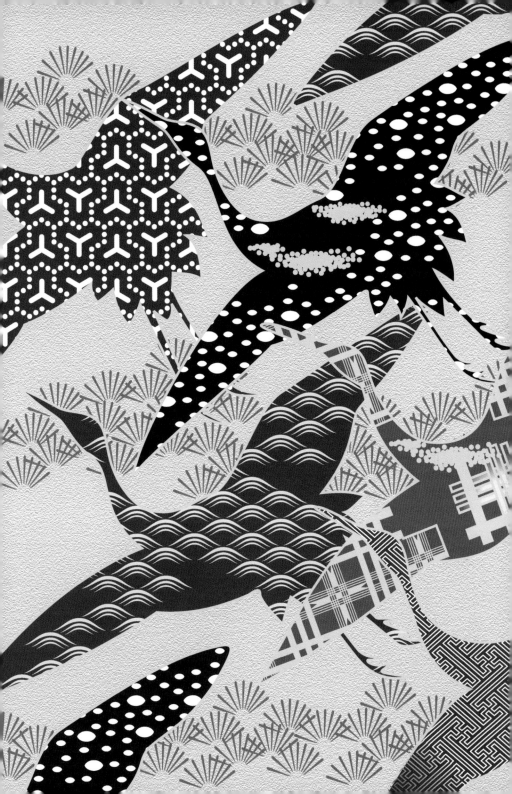

● CD 02 108 – 109
BUSH WARBLERS

Sometimes referred to as "the herald of spring" or "the flower viewing bird," the beauty of its song has inspired countless verse in the Manyoshu. All the more reason why the rarity of the appearance of this much loved bird in traditional patterns should be so surprising. But, if our predecessors had not expanded upon the olive-brown color of the back of the bush warbler, rendering it in a greener tint to express the differences between it and the sparrow, the bush warbler may have been considered little more than another singing bird. One would be disheartened, as well, if the hanafuda rendition of plum and the bush warbler were said to be a Japanese White-eye.

1 **A stencil-dyed rendition of plum and bush warblers** ●CD 02_108 Without a doubt a composition rendered on a hanafuda card. Devoid of clouds, this modernistic illustration is probably a relatively recent work.
2 **Plum and bush warblers rendered on an Urushi-e lacquered letter box** ●CD 02_109 The original work expresses the ancient tree more powerfully. The expressive demeanor of the bush warbler counterbalances the overall antiquated feel of this example.

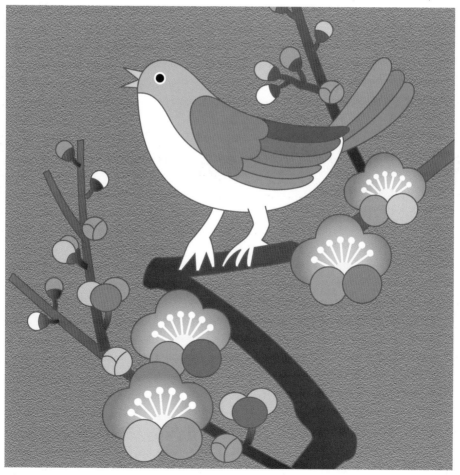

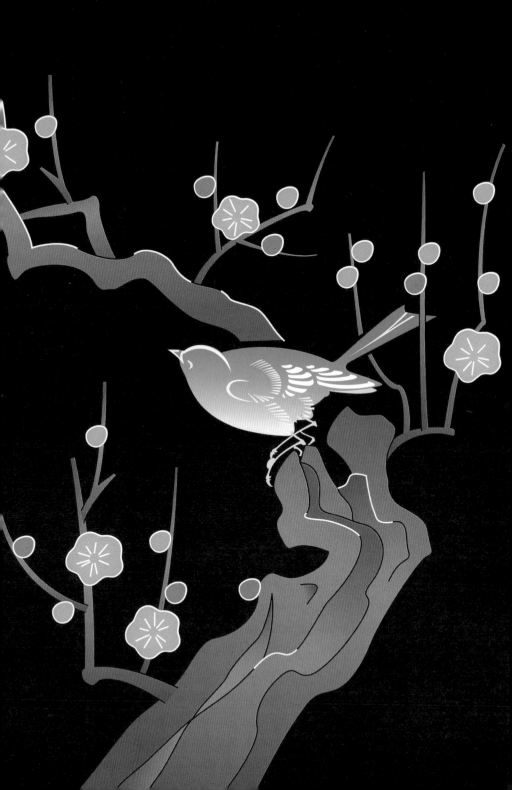

● CD 02 110 – 113
SWALLOWS

Sporting the former Japanese names "Tsubakurame" and "Tsubakuro," in flight these birds are like black arrows cutting through the air. These patterns were used here because of the inherent beauty of their tails, their lean and agile physique and their dynamic qualities. While there are certain design qualities (color transitions, combinations, etcetera) that examples such as that in 113 share with other patterns, it is the swallow itself that gives one a sense of crispness in the air.

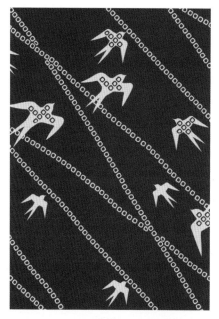

1 Flying swallows rendered on dappled cloth
● CD 02_110 A simple and honest work of excellence in which dappled spots reminiscent of rainfall come together in a seemingly mediocre expression of perspective of small and large flocks of flying swallows.

2 Flying swallows rendered on antique *Yuzen* print fabric
● CD 02_111 A staple among swallow patterns, this rendition shares its composition with example 113. The black color of the swallows comes to life with the airiness of this image.

3 A bouquet of flowers and flying swallows on antique *Yuzen* print fabric
● CD 02_112 The figure of the swallow is unique, but offers an interesting effect that does not wane in the midst of almost overpoweringly rendered flowers.

4 Willow and flying swallows on Chinese-style brocade fabric
●CD 02_113 Though at first glance the greatly flamboyant Chinese-style brocade together with the lean and agile swallows is discordant, processed with the sense of pigmentation unique to Chinese brocade, these swallows do not appear the least bit inharmonious.

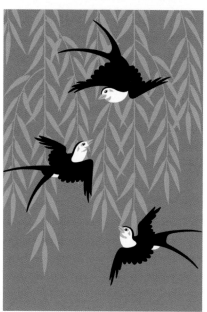

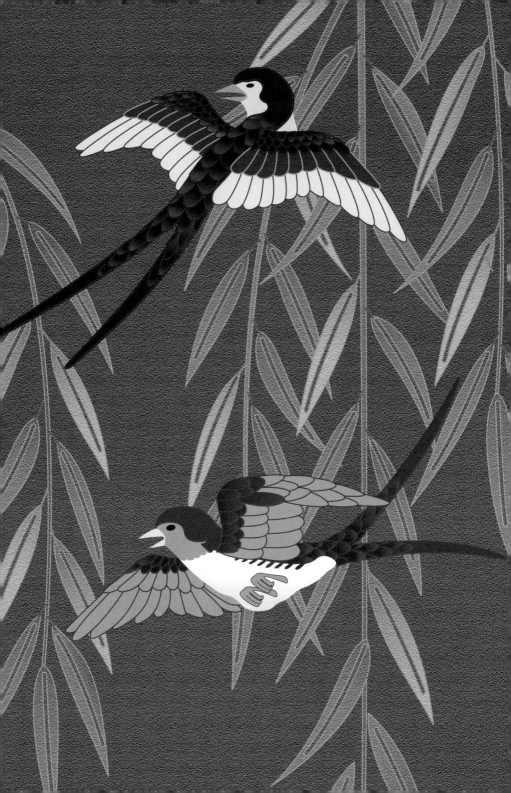

⬤ CD 02 114 – 117
SPARROWS

Patterns featuring the sparrow, the bird with which we are most familiar, have existed for ages. Because these birds are so close to our hearts, we quickly recognize the discordance between the eras in which their patterns were created, the backgrounds they are rendered upon, and the methods used to depict them. But if we consider traditional patterns not only in terms of their modern applications, but also for the dignity and quality that comes with their histories, and attempt to make their inherent authenticity our own, then this discordance becomes more of a suggestion that is difficult to discard.

1 Plump sparrows on antique *Yuzen* print fabric
⬤ CD 02_114 The term "plump sparrows" refers to sparrows that fluff their wings in midwinter. It also refers a type of knot used to type sashes. In the realm of patters, it is used to refer to the name of a finite form.

2 The sparrow in traditional pattern - 1
⬤ CD 02_115 Though the design leans slightly toward realistic expression, the charmingly rendered fundamental form of the sparrow will never become outdated.

3 The sparrow in traditional pattern - 2
⬤ CD 02_116 A unique portrayal. The overall design is a rendition of several tens of nimble sparrows.

4 Sparrows and bamboo rendered on *Maki-e* lacquered furniture
⬤ CD 02_117 The archetypical bamboo and sparrow pattern. Unerring omission and precise depiction come together in this excellent work that is dignified, yet approachable.

● CD 01 118 – 121
HERONS

Though its majestic good looks may be second only to the crane, the frequency with which it is rendered in patterns is testimony to the familiar beauty of the heron. The bird's distinctive crest and eyes, and the shape of its neck in flight. The light humor that seems to exist somewhere in every pattern is part of the charm of the heron pattern.

1 Reeds and herons on an *Urushi-e* lacquered tray
● **CD 02_118** An exceptional use of distortion in this rendition of herons. One is surprised at the timeless and keen sensation in this example.

2 Reeds and herons on a *kariginu* kimono
● **CD 02_119** Charming herons that share a roundedness with the reeds. Standing or in flight, both forms of the heron are humorous.

3 Reeds and herons rendered on a Maki-e lacquered inkstone case
● **CD 02_120** Though a somewhat picturesque rendition, the plumage has been deftly drawn in a neat designlike fashion.

4 Herons on a wall decoration
● **CD 02_121** Here, the herons are rendered three-dimensionally, creating a refreshingly cool spatial effect.

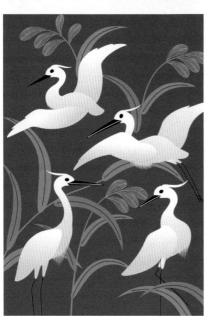

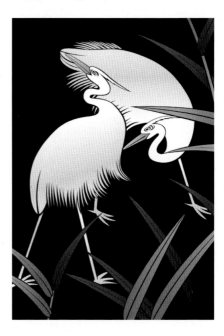

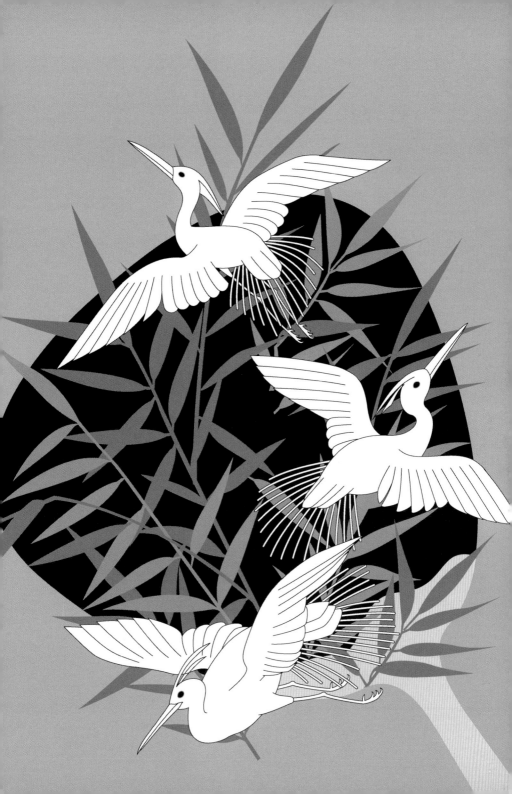

● CD 02 122 – 123
WILD GEESE

Feigning elegance, in Japanese we sometimes refer to a letter as "gansho." The origin of this phrase lies perhaps in the sight of wild geese soaring against the rose-colored sky as if keys or beams, an image perhaps evoked in the ancients at the vision of the birds to whom they had entrusted their letters protected in flight by their brothers. The patterns of wild geese depict a physical form redolent of a certain familiar sense of sorrow. One also gets a sense of this wistfulness from the combination of the moon and wild geese (compare these images to example 210 in the "Moon" chapter).

1 Wild geese rendered on a short-sleeved Kaga *Yuzen* print kimono
● CD 02_122 Here we discover a streamlined form that seems to herald the advent of the airplane of the future. One goose is expressed with embroidered accents.
2 Reeds and herons rendered in *Maki-e* lacquer
● CD 02_123 The wild geese descending toward the reeds are rendered with a humorous roundedness that softens the typical dignity of *Maki-e* works.

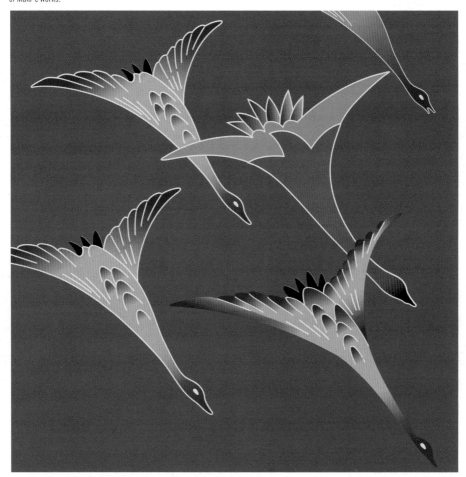

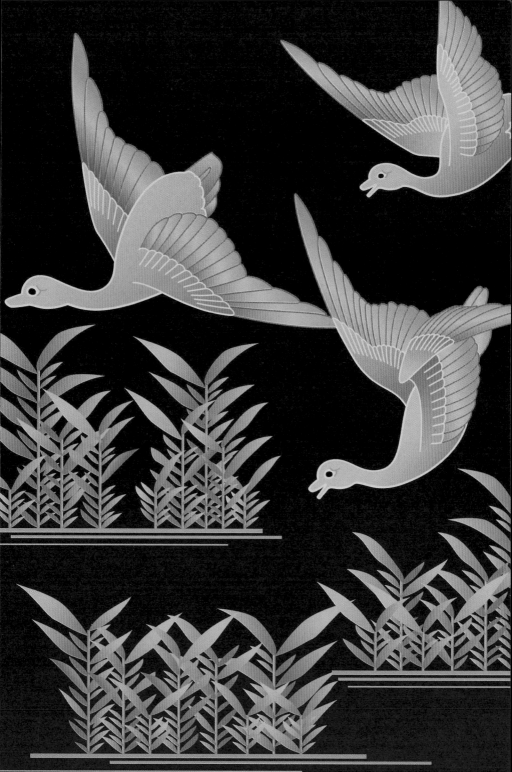

⬤ CD 02 124 – 127
PLOVERS

Though plovers also fly in flocks, they do so free-spiritedly, without the same tidy formations. Spatial aspect can be immediately broadened simply by adding plovers to the waves in a pattern, and because of the charming nature of their forms and movements, they have been used in widely from time untold in ancient patterns. Far from limitless in their diversity, however, the designs of the plover have settled into finite stylized form. Being finitely stylized means that they are universally recognized, but also that they run the risk of being stereotyped.

1 A plover pattern on a dyed short-sleeved kimono
⬤ **CD 02_124** The figure of the plover in flight is rendered with a few variations. This is perhaps a necessary strategy when the plover is the central player in a pattern.

2 Reeds and plovers on antique *Yuzen* print fabric
⬤ **CD 02_125** Plovers expressed in an somewhat rigid but often used style in traditional patterns; adding variation to the form of some of the birds lends diversity.

3 Plovers rendered on dyed antique fabric
⬤ **CD 02_126** Adding picturesque shadow to the stylized form of the plover and the use of a similar visual element in the rendition of the waves strips this example of the stigma of stereotype.

4 A plover pattern rendered on antique *Yuzen* print fabric
⬤ **CD 02_127** These, too, are stylized renditions of the plover, but the addition of flowers to the form of the birds in an expression that prompts the observer to name them "flowered plovers" is well-suited to *Yuzen* print.

● CD 02 128 – 129

MANDARIN DUCKS

"Aiba" and "omoiba" refer to the feathers of the mandarin duck during the mating season when a portion of the wings of the birds transform to resemble gingko. Indeed the perfect name "omoiba" is well-suited to the mandarin duck. Though their mating season is short, the mandarin duck beautifully transformed by its omoiba suggest the history of the mating pair and becomes the motif itself. Even in traditional patterns they are often rendered in radical hues.

1 Mandarin Ducks rendered on antique *Yuzen* print fabric
● **CD 02_128** Well-suited to gold brocade patterned damask weave and works of *Maki-e* lacquer, the mandarin ducks rendered here are the expression of light freshness.

2 Mandarin Ducks on Chinese brocade fabric
● **CD 02_129** There is an obvious rigidity in this expression. Though not a mating pair and a portion of the female is not visible, this is a novel composition.

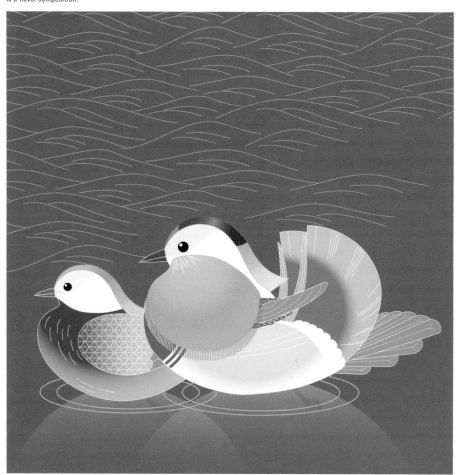

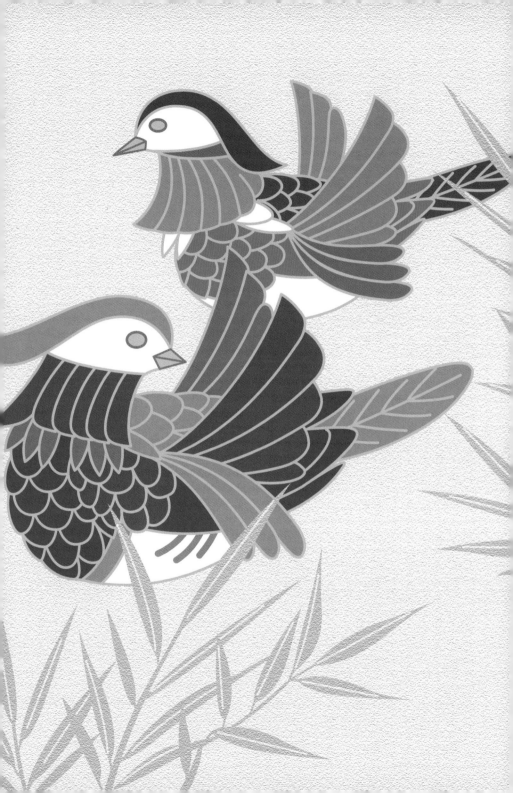

● CD 02 130 – 132
CHINESE PHOENIX-1

"Ho," the male phoenix, "O," the female phoenix; together they are the imaginary sacred birds. The imaginary animals – namely, the dragon, the phoenix, the Kirin, and the tortoise – that appear in this kind of ceremonious pattern are referred to as "shirei." Because of their imaginary nature, they are also the subject of abundant oral histories.

1 A flying bird arabesque pattern rendered on a thick sheet

● **CD 02_130** "Thick sheet" refers to clothing fabric. The flying bird pattern arabesque is a staple among arabesque patterns.

2 Phoenixes rendered in circular patterns on a waist sash

● **CD 02_131** The ornate element of the phoenix is captured well in this crestlike attractive pattern.

3 Flowers and phoenixes rendered on antique embroidered fabric

● **CD 02_132** Though the combination of the woven pattern and embroidery lends a certain heaviness, this design is enwrapped in a gentleness atypical of phoenix patterns.

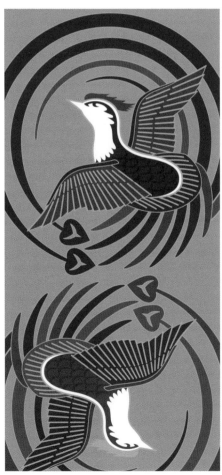

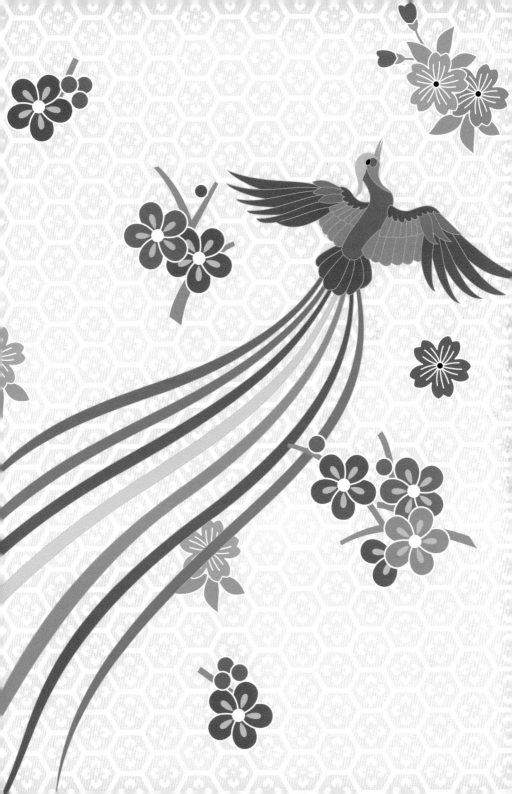

⬤ CD 02 133 – 134
CHINESE PHOENIX-2

1 Chinese Phoenix amidst cursively rendered *tatewaku* on foil-fabric

⬤ CD 02_133 While the use of gold thread lightens this weighty design, phoenix patterns display a proclivity for such excessive decoration.

2 Flowers and Phoenixes in embroidered rendition

⬤ CD 02_134 A flamboyant phoenix pattern sewn with gold and silver thread. Perhaps because it is difficult to duplicate the image of the original here, it is easier for us to appreciate the excellence of this illustration.

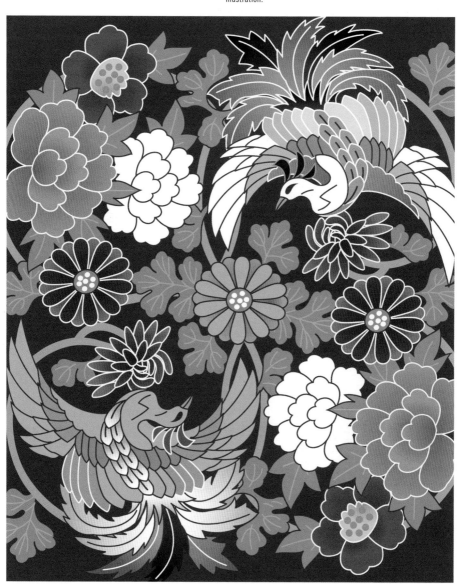

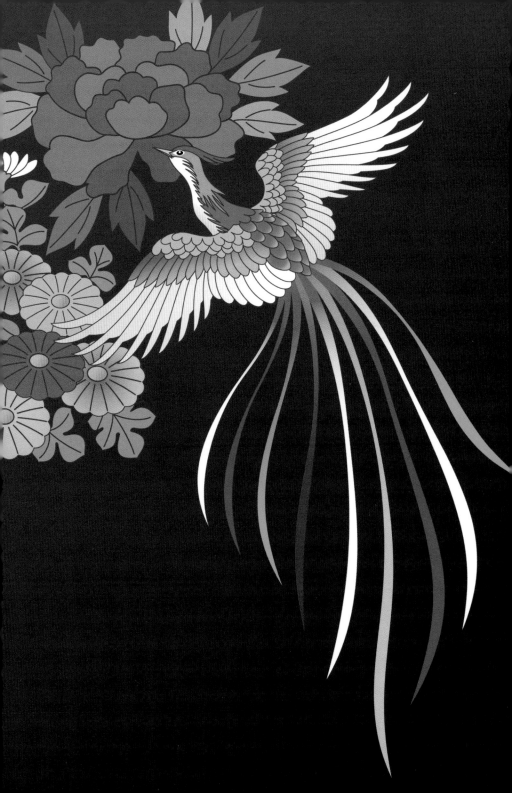

● CD 02 135 – 137
PEACOCKS

Because the form of the peacock is so beautiful, it is often worshipped as a magical spell-king, despite the disgusting things (poisonous insects) it eats. Being the subject of such faith, then, lends significance to the peacock rendered in traditional pattern, and the more effective the design, the more pervasive the significance of the bird becomes.

1 A peacock pattern rendered on porcelain china
● **CD 02_135** Though one may demure at the realism of this peacock design on a utensil intended for food, it is a rendition that is true to the form of the bird.

2 A peacock pattern rendered on porcelain china
● **CD 02_136** A modern, sophisticated and elegant pattern.

3 A peacock on antique *Yuzen* print fabric
● **CD 02_137** A realistic, orthodox rendition of the peacock that is flawlessly beautiful. The diverse flowers in the original have been omitted here.

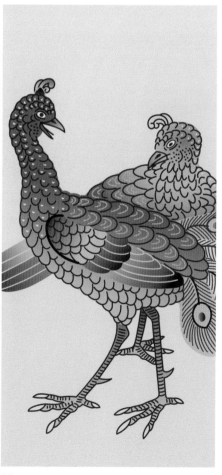

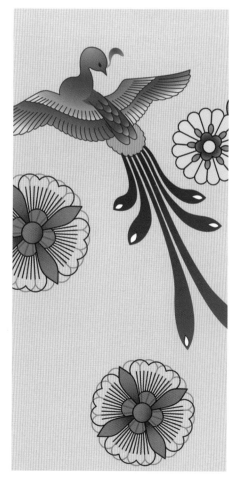

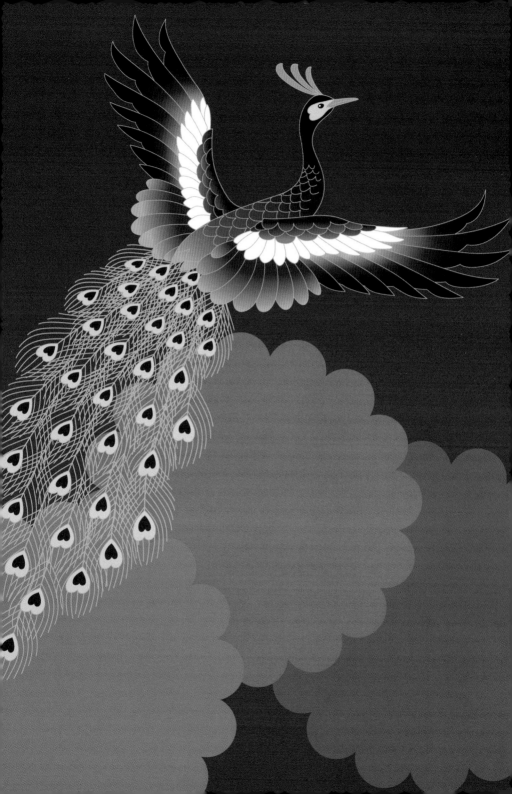

● CD 02 138

CORMORANTS

Cormorant fishing has an ancient history. They are even referred to in the *Nihon Shoki* (the oldest chronicles of Japan). Despite its ubiquitous familiarity, there are no examples worth observing in traditional pattern. In terms of traditional pattern, perhaps something more than its inherent beauty was required, such as the origin and history or the convincing faith that gives significance to the peacock introduced in the previous section.

1 A cormorant pattern on antique *Yuzen* print fabric
● CD 02_138 One can recognize the cormorant from the patches around its eyes, the differences in its tail feathers and its feet. Moreover, rarely do you find patterns of wild geese soaring toward turbulent waves.

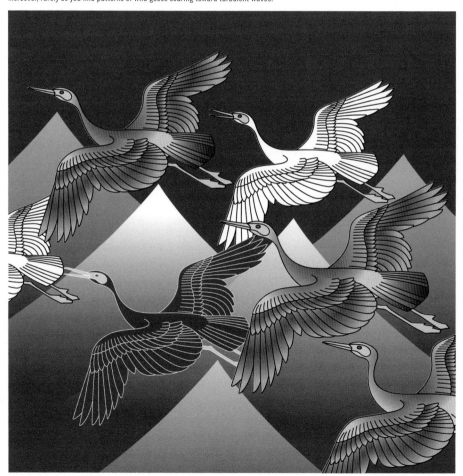

Chapter 3
Wind
CD 03:139-197

● CD 02 139 – 142
FLOWING WIND

The flowing wind patterns would indeed be robbed of their elegance were we to refer to *Kacho fugetsu* (flower, bird, wind and moon) as *furyu inji* (the elegant appreciation of nature through artistic pursuits such as poetry, painting and calligraphy). Avoiding such physically explicit expressions through the use of other expressions that represent the significance behind tangible phrases such as *Kacho fugetsu* or *Setsugekka* (referring to winter snow, the autumn moon and cherry blossoms) lends a certain twist, giving one a greater sense of the richness of their spirit.

1 Flower rafts on a maiginu Noh costume
● **CD 03_139** The "flower raft" represents the finite form of the traditional pattern. Rendering the flowers that float on the water's surface as rafts, then adding to that the actual form of a raft, lends greater significant to the sentiment behind to the artist's rendition of the flower raft, creating patterns replete in emotional expression.

2 Thunder and flower raft patterns on embroidered foil-fabric
● **CD 03_140** One gets the sense that the falling cherry blossom is the expression of oneself refusing to give heed to the vagaries of the weather as he takes pleasure in the moment.

3 Flower rafts rendered on antique *Yuzen* print fabric
● **CD 03_141** Through the use of elegant motif and hues that tell of alarming portent, this rendition teaches us that the flower raft is by no means usual.

4 A hand drum and illustrated booklets on antique *Yuzen* print fabric
● **CD 03_142** This piece implicitly suggests that elegant play and enjoyment are born not of leisure but of a refined latitude.

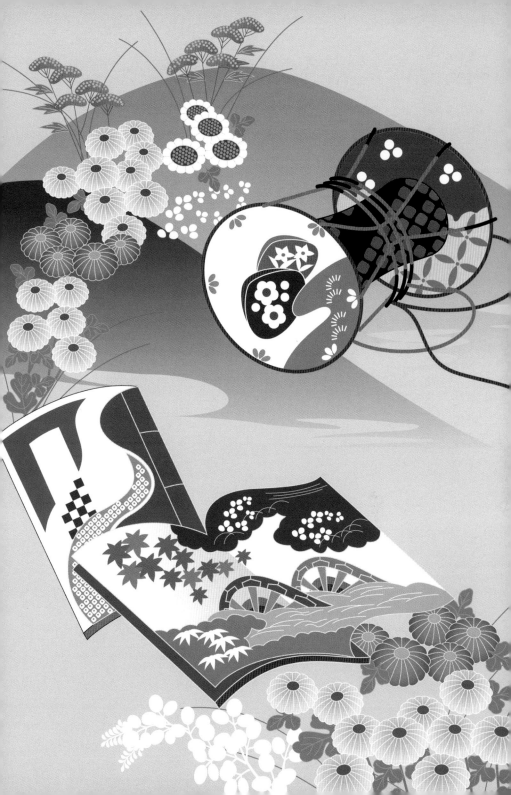

● CD 02 143 – 146
FLOWER AND WIND

The flower and the storm are inseparable. The storm is all the more reproachful for the preciousness of the flower. In different terms, though we hold a covetous affection for the flower, such is the whimsical nature of the human psyche that, as embodied by the phrase *shizukokoro naku hana no chiruran* (the cherry blossom falls turbulently without ever learning to be calm), more than the mundanity of blossoms falling quietly to the ground, we would rather experience the theatrical state where anxiety stimulates the emotion.

1 Falling cherry blossoms on antique *Yuzen* print fabric
● CD 03_143 Though this piece holds no new discoveries, it is the epitome of the beauty of the falling cherry blossoms that will the observer to attribute a certain truth to them.

2 Falling cherry blossoms on antique *Yuzen* print fabric
● CD 03_144 Though similar to the previous example, this pattern is perhaps more realistic.

3 Leaves and blossoms blown together on antique *Yuzen* print fabric
● CD 03_145 A briefly entertaining moment similar to that depicted in example 091 in the Flower section, the scattering of just a few flowers is imbued with a charm within which we can almost feel this single gust of wind.

4 A Tatsutagawa river pattern on a *Maki-e* lacquered hand drum case
● CD 03_146 Maple leaves in flowing water are the trademark of the Tatsutagawa pattern. The same verse expressed abundantly from times long past is also the subject matter of numerous patterns.

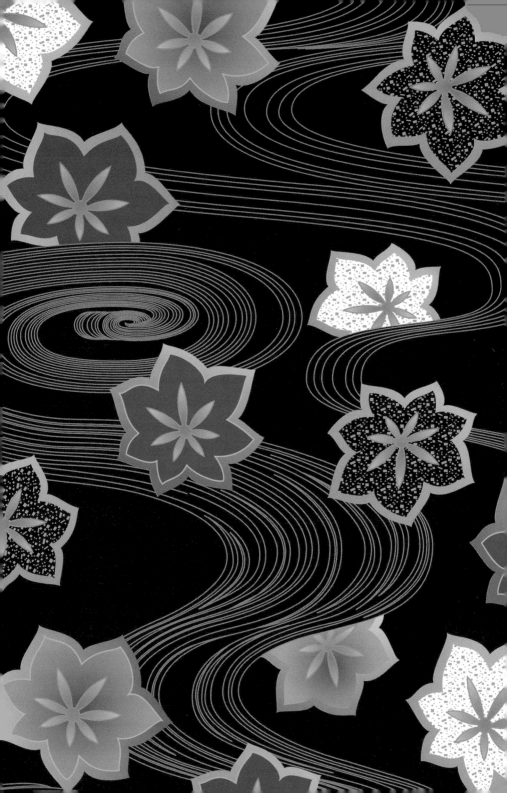

● CD 02 147 – 148

COURTLINESS-1

Though the Japanese term for courtliness, miyabi, signifies elegance and refinement, it is difficult to ignore the strong implication of courtliness, a sense of the many scenes of court life taken from the pages of the *The Tale of Genji*. No doubt, in the mind's eye of the Japanese observer, these elegant patterns would conjure images of the easy flowing of time, the esthetic of beauty and the graceful figure of a woman, indeed, all of the images with which they are so familiar with from *The Tale of Genji*.

1 Autumn grasses rendered on an antique *Yuzen* print fabric fan
● CD 03_147 The fragile appearance of the autumn grasses reminds us of a scene from *The Tale of Genji*.

2 A rowel pattern on a hitoe unlined kimono
● CD 03_148 True to the term "flower wheel," wheels of wisteria blossoms are drawn to elicit a sense of courtliness. But certainly it does not hold a candle to the carriage of Lady Fujitsubo.

● CD 02 149 – 150
COURTLINESS-2

1 A Genji incense pattern rendered on antique *Yuzen* print fabric

● CD 03_149 Genji incense is a type of incense guessing game; the pattern itself if is highly compositional and elegant. The rough-woven bamboo fence is the central focus in this elegantly rendered scene.

2 Grace cherry blossoms on an embroidered figured silk short-sleeved kimono

● CD 03_150 From the bamboo blinds, lattice, koto and cherry blossoms, it is evident that this is a rendition of a scene from *The Tale of Genji*.

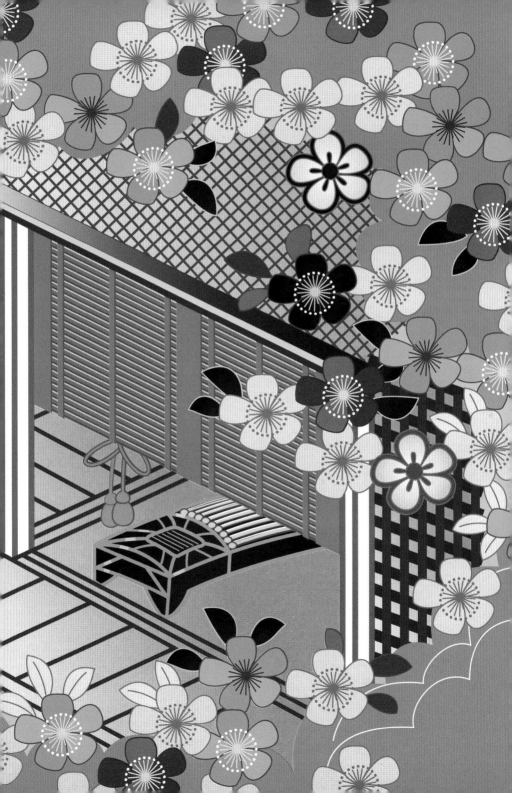

● CD 02 151 – 154

FANS

Though size determines the strength of the breeze generated by these diversely formed fans, their shape notwithstanding, not matter what form they take, be it fully open, closed or half-open, nothing detracts from their methodological form. Moreover, we never tire of them because the purely Japanese composition of their images and their convenient shapes capture scenes, invite stories and create atmosphere.

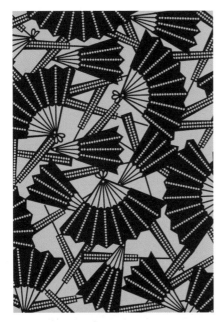

1 Fans rendered in a *chumon* (medium-size) pattern
● CD 03_151 This work incorporated all aspects of the figurative beauty of the fan, creating an alluring pattern simply by scattering them on top of each other.

2 Paper balloons and fans on antique *Yuzen* print fabric
● CD 03_152 In addition to paper balls, there are also paper balloons. Does one use the fans to blow air toward the paper balloons in this charming child-oriented work?

3 Fans and cherry blossoms rendered in Chinese-style brocade
● CD 03_153 Half-open fans and weeping cherry tree blossoms. Each of the multiple designs is embroidered with multiple types of colored thread for variation.

4 A rendition of fans and flowers in a stream on antique *Yuzen* print fabric
● CD 03_154 In this exquisite composition, the flowing water stripes are rendered in multiple alternating layers; in the flowing water are depictions of fans and seasonal flowers, while the green stripe representing land is decorated with wisteria and pine.

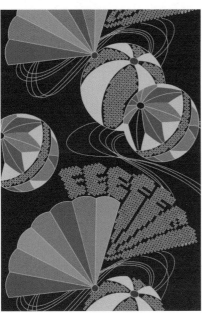

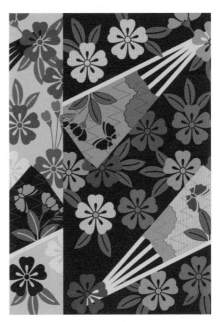

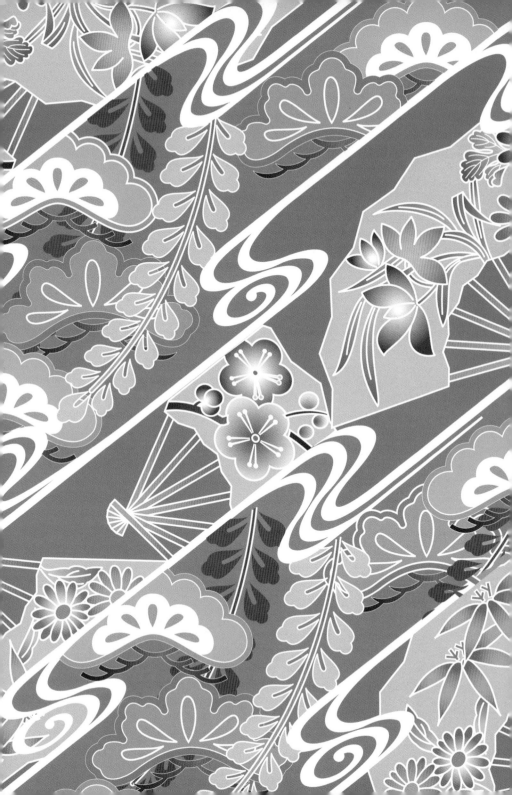

● CD 02 155 – 158
WAVES AND GENTLE WHIRLPOOLS

Among traditional patterns, in addition to the more realistic rendition of waves, there are also patterns purely dictated by whimsical sensitivities. Therein lays a charm that lives up to the name *Kacho fugetsu*. This charm exists in none other than the room we have in our hearts for enjoying every moment, every movement of the surging waves and the cold water.

1 A komon pattern of Matsukata waves
● CD 03_155 To use a metaphor from music, waves and gentle whirlpools are akin to the unlimited variations originating from a single verse of a theme.

2 Stencil-dyed rolling waves
● CD 03_156 The use of the stencil-dye technique lends an air of artlessness to this piece. A gentle and patient rendition that can be either delicate or naïve, depending on its expression.

3 Bamboo waves rendered in a *chumon* pattern
● CD 03_157 Though they may not all be rendered as successfully, we are inspired to use this pattern in other motifs as well.

4 Gentle whirlpools rendered on antique *Yuzen* print fabric finished in gold leaf
● CD 03_158 Flow, whirlpools of water, flowers of the four seasons. A multiple-tiered three dimensional pattern with a poetic sentiment.

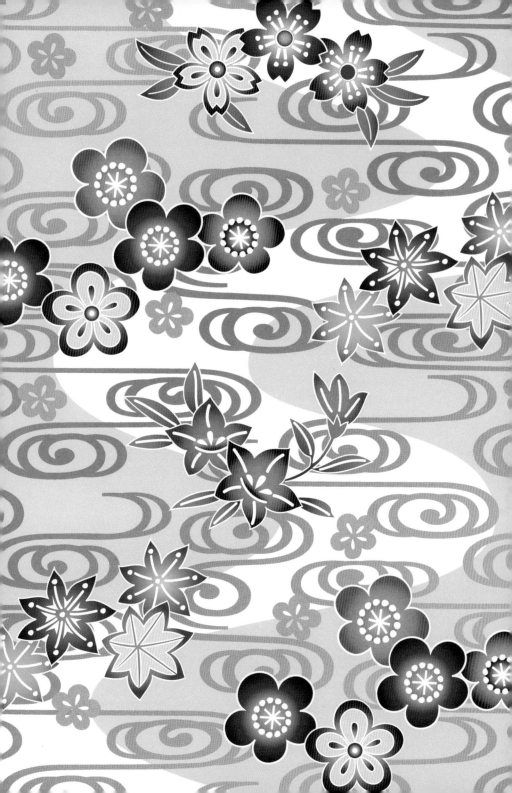

● CD 02 159 – 162

SOUND OF THE WIND

The sound of the wind tells of the advent of the seasons, it surprises, it distorts and confuses our desires. The invisible wind that shake the leaves on the trees has been rendered in a diverse array of songs. Among the traditional patterns are superior works that try not to depict the wind using some artificial method, but rather, to suggest to the observer the existence of wind through the effective use of materials.

1 A komon pattern of pine and eddies
● CD 03_159 Within the eddies of the local pine-strewn coastal waters is a suggestion of extremely powerful winds.

2 Falling blossoms on fine silk striped woven material of impressed gold foil
● CD 03_160 It would seem that the cherry blossoms that fell on the koto strings generated an ever so small sound. While *kando* (side street) is supposed to be suggestive of the Silk Road, I prefer to think of it as a peaceful digression.

3 Pinwheels on antique *Yuzen* print fabric
● CD 03_161 A simple design that prioritizes the form of the charming pinwheels even as it expresses the wind itself.

4 Drums on antique *Yuzen* print fabric
● CD 03_162 Dotted patterns are used as a sort of background in this expression of wind and fragrance.

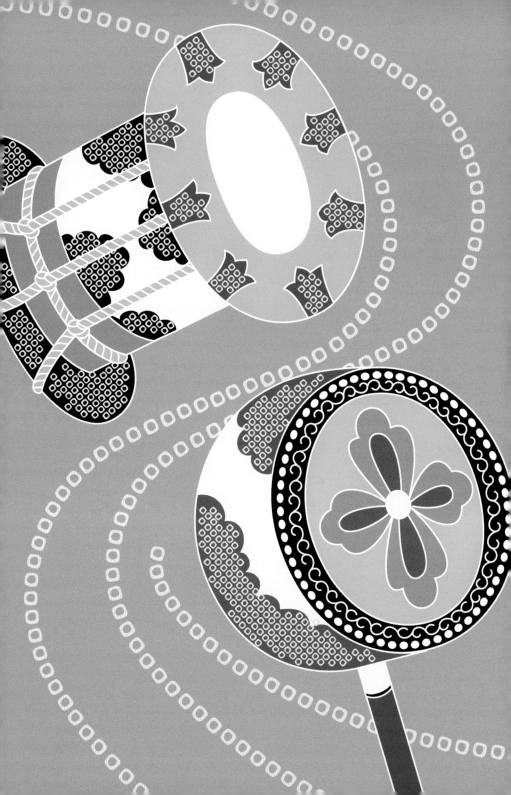

● CD 02 163 – 166
WIND IN FORM

Intoned in the on-kun reading of the Japanese term, the phrase "fushi" reverberates with allusions to "appearance" or "beautiful form." Impossible to capture, it is not until we see the bending grasses and trees that we get the sense of whether the wind is born of a typhoon or the gentle breezes of spring. The wind in traditional patterns is always rendered in tranquil and elegant form.

1 Weeping willows on crepe silk *Yuzen* fabric
● **CD 03_163** The lack of uniqueness of the weeping willow gives its designs profound breadth.

2 Autumn grasses on an embroidered decorative collar
● **CD 03_164** This pattern of autumn grasses and bush clover swaying in the wind is rendered from a close-up perspective.

3 A bamboo forest pattern on an *uchikake* unbelted women's outer garment
● **CD 03_165** This figurative rendition a forest of bamboo so different from the typical bamboo pattern has a certain allure that is perfectly suited to the verse, "In the gathering dusk of this evening, I hear a rustling wind blowing faintly through the small bamboo grove around my house."

4 Autumn grasses on a short-sleeved kimono
● **CD 03_166** One can feel the winds of the advent of spring in the thoroughwort's supply form in this example of a masterful work that deserves to be called more than "autumn grass."

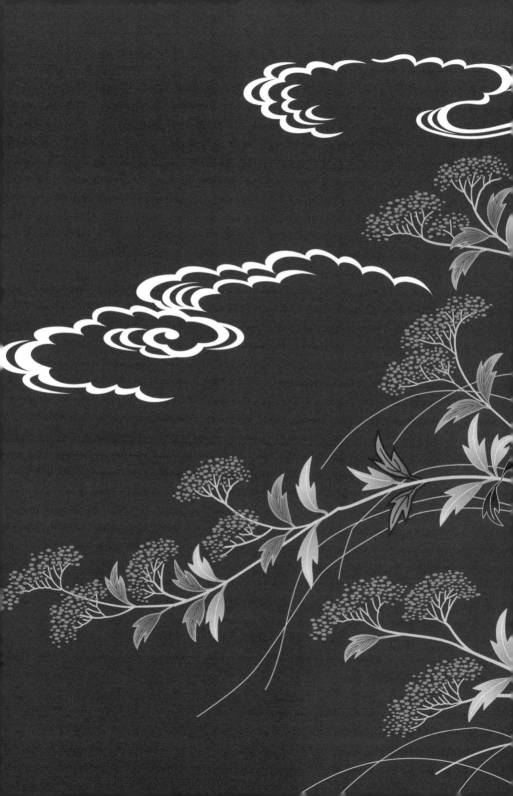

● CD 02 167 – 170

LANDSCAPES-1

Landscape patterns are rendered as the "things natural" patterns of *Kacho fugetsu*. But because landscapes that that give one a sense of vigorous interest depict buildings, natural mountains and rivers and other seasonal landscapes, they placed in their entirety within a single space, making it impossible to render them in close-up perspective. For this reason, these patterns have been separated into the "Landscapes" sections which feature "things natural" that have only limited elements, and the "Things Natural" sections which introduce items that characterize the poetic verse of the things natural in each season.

1 A komon pattern of rural houses
● **CD 03_167** Country homes and the rustic landscape surrounding Shiohama seem to solicit the less than subtle interest of city folk.

2 Distant mountains rendered on *Bingata*
● **CD 03_168** Distant views of distinctive mountains and the beauty of the sphere of life of the river and flowers are introduced in a variety of forms.

3 A waterwheel on antique *Yuzen* print fabric
● **CD 03_169** Though actually somewhat disconsolate, even the landscape of an agricultural community can become as elegant as this rendition when viewed with a discerning eye for charm.

4 Autumn grasses on a short-sleeved kimono
● **CD 03_170** This was most likely dyed for a child's kimono. Bright and wholesome, this pattern makes the observer happy, as if he were reading a picture book.

● CD 02 171 – 172
LANDSCAPES-2

1 A bamboo fence on antique *Yuzen* print fabric
● CD 03_171 The *magaki* bamboo fence is a coarsely meshed hedge of firewood or bamboo.

2 A bamboo fence on a short-sleeved kimono
● CD 03_172 Surrounded by flowers, this *magaki* fence that has a certain appeal. Magaki fences are never rendered by themselves as patterns.

● CD 02 173 – 176

THINGS NATURAL-1

Butterflies-1/Embodiment

The butterfly seems to be adorned in their own kimono, one that has already been decorated with patterns. Beautiful and seemingly drawn from nature, the symmetrical patterns are somewhat organized. Among these patterns appear designs that seem to have been given great thought. If beautiful patterns rendered without the hardship of crafting do in fact exist, all that remains is to add variety to coloration, form and expression, and to harmonize these aspects with the media used to implement them. One can go so far as to assert that there is, in fact, little evidence of hardship in the crafting of the traditional butterfly pattern.

1 Butterflies on embroidered foil-fabric
● CD 03_173 Shining golden flowers and butterflies. It would seem the artist whished not to depict butterflies gathering around flowers, but, rather, to merge the wild dance of the butterfly with the dance of the flower petals.

2 A butterfly on antique *Yuzen* print fabric
● CD 03_174 From the trajectory as it flies off, one senses more the sensuality than the mystery of the butterfly.

3 Butterflies on embroidered fabric
● CD 03_175 Rendering two types of butterfly in diverse hues gives the impression of multiple types of butterflies. For the background the komon design

4 Butterflies on antique *Yuzen* print fabric
● CD 03_176 Anyone could have conceived this pattern, but not the way the sun illuminates this scene.

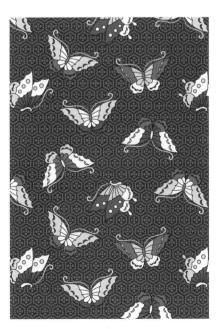

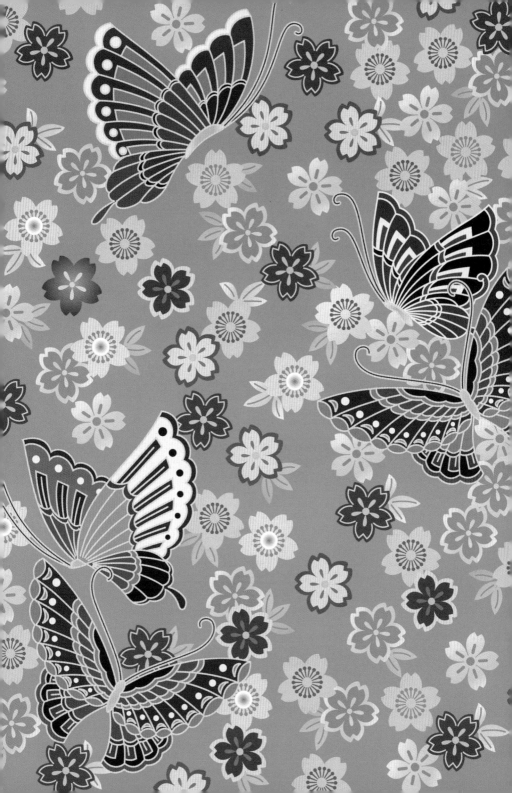

● CD 02 177 – 180

THINGS
NATURAL-1

Butterflies-2/Design
Some patterns use the same method to render variations of the subject, while others give the observer a sense of the intentions of the designer with regard to the subject.

1 Butterflies on an *Urushi-e* lacquered tray
● CD 03_177 The purposeful feelers of the lead butterfly are rendered exceptionally long.

2 Butterflies on an *Urushi-e* lacquered tray
● CD 03_178 The differences between the rounded butterflies in example 177 and the sharpness of the butterflies here is truly interesting.

3 Butterflies on *Tsujigahana*-dyed fabric
● CD 03_179 Unique to the *Tsujigahana* dying method, this expression masterfully gives birth to gently curving lines.

4 Butterflies on Chinese-style brocade fabric
● CD 03_180 Design flowers are combined with the butterfly pattern. The typological expression of the flowers is somewhat incongruous with that of the butterflies.

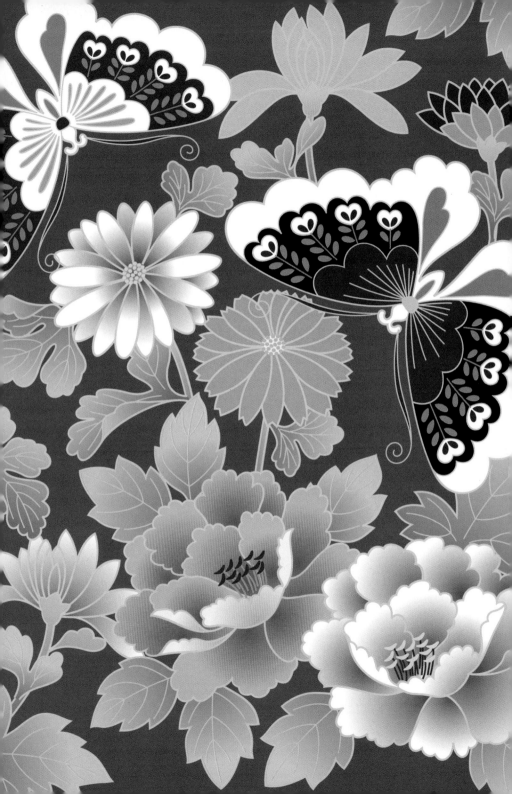

● CD 02 184 – 182
THINGS
NATURAL-1

Butterflies-3/Freestyle

Among the many typological butterfly patters, it this kind of freedom of expression that stands out. Even better if this freedom evolves to become the finite figure of the traditional pattern. In this way, all manner of material adhere to a particular method of expression to become the basis of pattern crafting.

1 **Butterflies on tie-dyed fabric**
● CD 03_181 Though the dapple dye method is somewhat daunting, the simple silhouettes are buoyant.

2 **Butterflies on antique *Yuzen* print fabric**
● CD 03_182 This rendition employs a fresh sensitivity to shed itself of typological expression. This sensitivity also comes to the aid of the typological clouds and flowers in this luscious pattern.

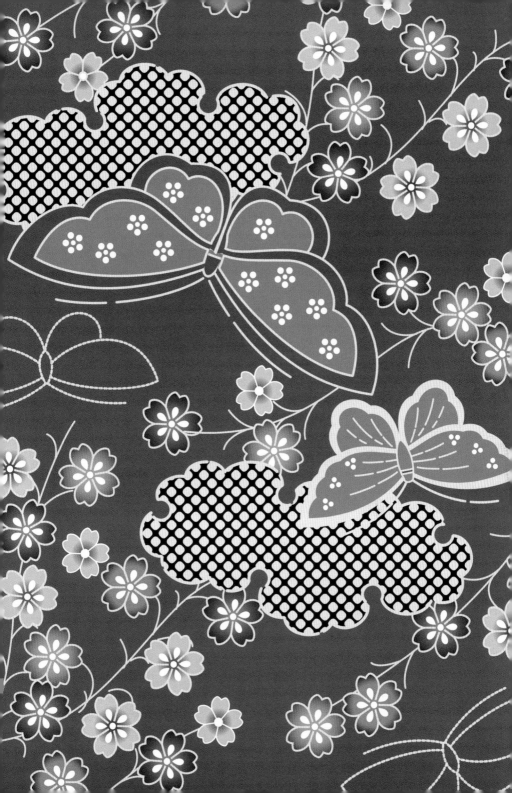

● CD 02 183 – 184

THINGS
NATURAL-1

Butterflies-4/Originality

Even with the same subject, expressions of the subject that exceed the subject itself often result in renditions that are at once figurative yet non-figurative, designs that make us realize the completely different intentions of their creators. Such examples show extremely fresh forms of workmanship.

1 *Koetsu* butterflies rendered on *Kyokarakami* paper
● CD 03_183 How like the work of the master artist! Koetsu and Korin — one is struck dumb gazing at one of their patterns.

2 Butterflies crafted from noshi gift wrapping paper on a short-sleeved kimono
● CD 03_184 Each one of the noshi crafted in different shapes is in and of itself a figurative pattern. Though it is true that the art of crafting paper to form cranes and butterflies is by no means new, these butterflies are certainly creative.

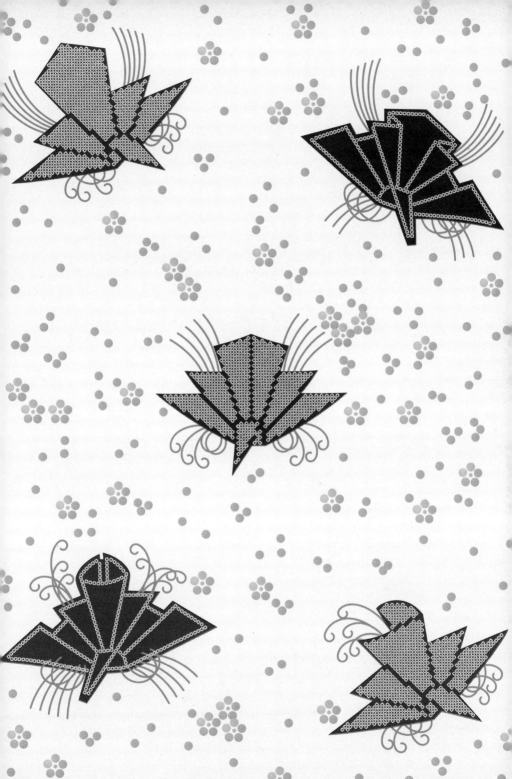

● CD 02 185 – 188
THINGS NATURAL-2

Dragonflies

It is well-known that the dragonfly is also referred to as the "insect of victory." Though the dragonfly may hold a subordinate position with relation to the butterfly introduced in the previous section, it also has qualities that are worthy of recognition. As with the poetic verse depicting things natural in the summer season, from the dragonfly patterns implemented on weapons of war, as well, we get a glimpse of the flexible sentiment of the ancients toward nature.

1 Dragonflies on antique linen fabric
● **CD 03_185** A pattern that is best suited to simple and direct expression, such as that of a gentle and rustic landscape.

2 Dragonflies on an *Urushi-e* lacquered tray
● **CD 03_186** Thought to be the partner of the Urushi-e lacquered tray butterfly pattern (example 179), this rendition is already an early autumn landscape.

3 Dragonflies on a light cotton *yukata*
● **CD 03_187** The rounded lines of the morning glory in contrast with the crisp pointed wings of the dragonfly conjure the image of a clear summer night sky.

4 Dragonflies on a *kataginu* sleeveless jacket
● **CD 03_188** Worthy of the garment of a samurai, this bold and frank design is a true masterpiece.

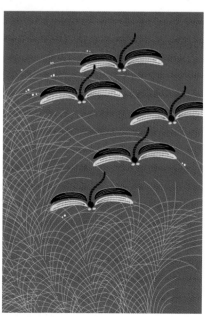

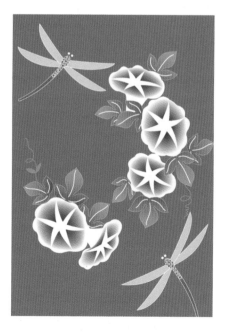

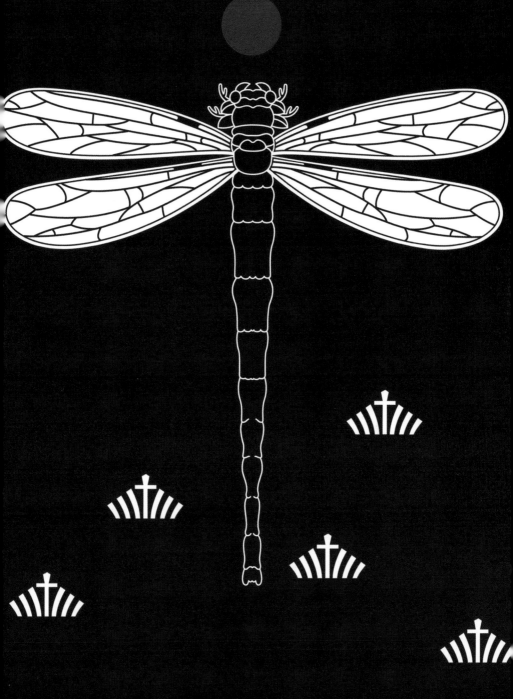

● CD 02 189 – 192
THINGS NATURAL-3

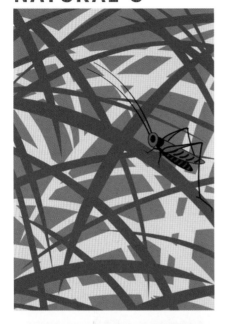

Insects

The insects that add sound to the visual aspect of autumn are rendered together with patterns of autumn grasses. Though in some patterns these insects appear alone, such patterns are rather rare. The more true to nature an insect is expressed, the more grotesque its demeanor, indeed, the less suited it becomes as the subject of patterns. However, they are also indispensable for their contribution to the rendering of the romantic scenes of autumn fields.

1 A lone bush cricket amongst autumn grasses
● CD 03_189 A diminutive bush cricket (also read in Japanese as "kirigirisu") rendered on the side of an old Go game board. The cricket is included also in the arista patterns on illustrated ceramic ware crafted by Ogata Kenzan.

2 Insects on a *Maki-e* lacquered ink stone case
● CD 03_190 Thought to be rendition of the long-horned grasshopper and hexacentrus japonicus. A pattern that has a certain charm that harmonizes well with Maki-e lacquer.

3 Bell crickets on a *Maki-e* lacquered utensil
● CD 03_191 A charming design of bell crickets. Drawn on a utensil whose texture is almost visible, one can experience the tenor of autumn even without the autumn grasses.

4 Cicada on a *menuki*
● CD 03_192 Made to cover the *mekugi* used to fix the sword center, the *menuki* is a decorative fixture. Though a example of minute chasing workmanship, when enlarged there is strength in the precise design.

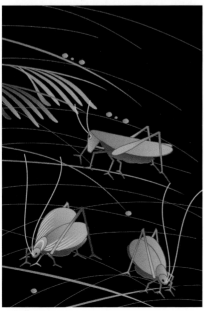

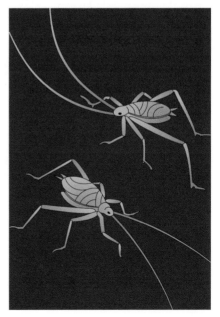

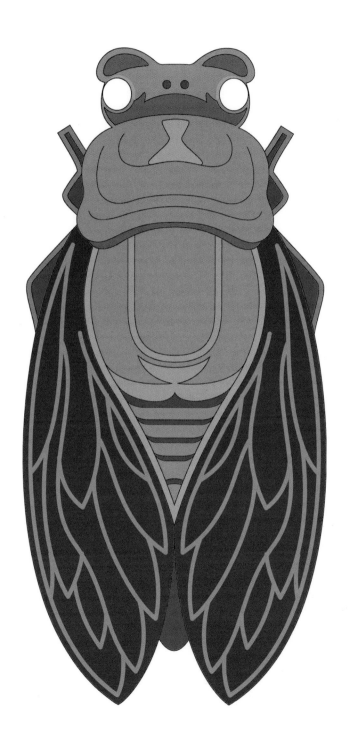

● CD 02 193 – 194

THINGS NATURAL-4

Fish

The first fish pattern called to mind is that of Koi, the carp. Rendered not only in traditional pattern, the carp has origins in a variety of oral histories, making it the subject of Japanese painting and attributing to it a kind of intimacy. This is epitomized in the Toryumon, the dragon gate pattern, and the Koinobori of flown in seasonal festival of May. Though the alluring color and markings of the goldfish make it perfectly suited as the subject of patterns, the extraordinarily small amount of their patterns can perhaps be accounted for by the fact that the goldfish is a relatively new form among traditional patterns.

1 Goldfish on a fan
● CD 03_193 The facial expression of the goldfish swimming languidly in this work rendered to resemble a modern illustration.

2 Large pattern rendition of carp
● CD 03_194 A stencil-dyed rendition of the carp. In this often found realistic rendition of the carp, the simplistic forms seemingly rendered using the sharp edge of a sword are brilliant.

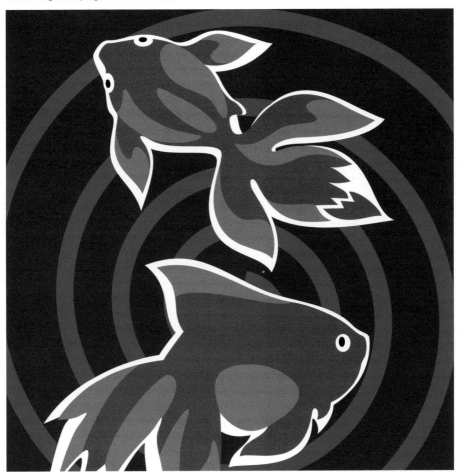

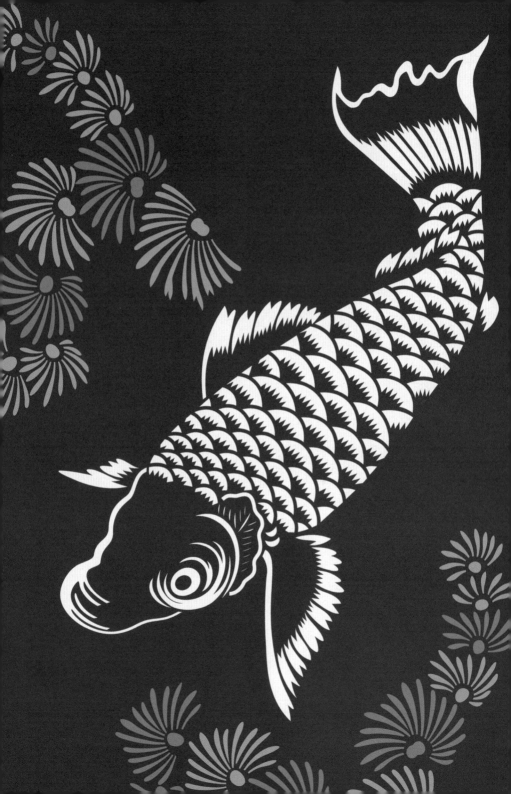

● CD 02 195 – 196
THINGS NATURAL-5

The New Year/ The Tanabata Star Festival/ The Tea Ceremony

There are not many patterns based on the unique customs, festivals, seasonal events and activities of a particular region. This could be due to their transient nature. Indeed, in order to display the beauty inherent in the utility of daily life, seasonal categorizations such as spring, summer, autumn and winter are certainly more appropriate.

The New Year
1 *A komon* rendition of *Hatsuyume* (the first dream of the New Year)
● **CD 03_195** The phrase "1. Fuji, 2. Taka, 3. Nasu" stands even today as a fortuitous first dream of dependent origination.

Tanabata
2 A *Tanabata* bamboo pattern on an *katabira* unlined cotton kimono
● **CD 03_196** The *katabira* is an unlined summer kimono usually made of raw silk or linen. An expression that simple and gentle, one that solicits a momentary brilliance and temporal misery.

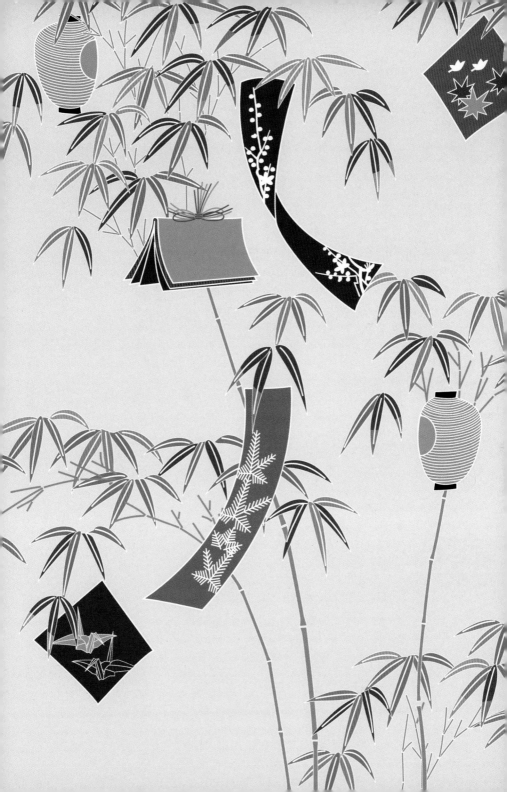

The Tea Ceremony
3 A komon pattern of tea ceremony utensils
⦿ **CD 03_197** A refined and masterful dotted rendition of slightly distorted tea ceremony utensils. Were this a background pattern, it could be used any time for purposed not limited to the tea ceremony.

Chapter 4
Moon
CD 04:198-250

● CD 04 198 – 201

MOON-1

There is an overwhelming amount of patterns in which the moon is depicted in a face-off with autumn grasses. As expressed in verse by Saigyo Hoshi, "*Nagete tote, Tsuki ya wa mono o omowasuru...*" (Should I blame the moon for bringing forth this sadness?), the Japanese sentiment is such that the moon is more significant for the tendency of the typical Japanese person to be drawn into the silvery world it seems to hold than as an object of mere enjoyment. What is more, no matter what the era, the moon has always had a compellingly mysterious power capable of moving our hearts and minds.

1 The autumn moon on a *Yuzen* print *kataginu* sleeveless jacket
● CD 04_198 Superbly elegant, this landscape is the counterpart of the masterpiece depicting a bellflower field against the backdrop of the rising moon on a *kataginu* sleeveless jacket.

2 The autumn moon on antique *Yuzen* print fabric
● CD 04_199 From the diverse hues of the leaves of the arista, this is probably a relatively modern pattern.

3 A winter snow, autumn moon and spring cherry blossom pattern on crepe silk
● CD 04_200 Flowers, moon and perhaps the bush vetch that thrives under the snow in this frank and charming contiguous expression of a winter snow, autumn moon and spring cherry blossom pattern.

4 The full moon on a *Maki-e* illustrated stationary case
● CD 04_201 Rough horsetail standing watch over a rising full moon. The straight lines of the rough horsetail combine with the glow to make a threatening moon.

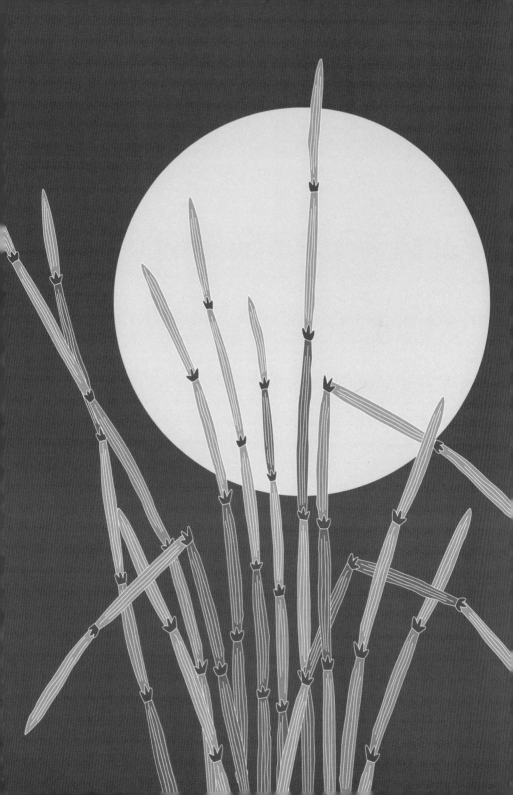

● CD 04 202 – 205
MOON-2

1 A *Korin* rendition of the moon on *karuta* playing cards-1
● CD 04_202 The card that reads *"Kumo no izuko ni tsuki yadoru ran"* (somewhere behind the clouds resides the moon). A refreshingly unrestrained and elegant rendition by Ogata Korin.

2 A *Korin* rendition of the moon on *karuta* playing cards-2
● CD 04_203 The card that reads *"More izuru tsuki no kage no sayakesa"* (See how clear and bright is the moonlight finding ways through the riven clouds…). How picturesque the penetrating heavens.

3 The moon rendered on an antique *Yuzen* print fabric fan
● CD 04_204 Though no as unique as the work of Korin introduced in example 203, the indirect depiction of the moon makes this a graceful picture.

4 The moon and rabbits rendered in *Urushi-e* lacquer
● CD 04_205 As if the rabbits had just fallen from the moon, this picture is both humorous and easy to like.

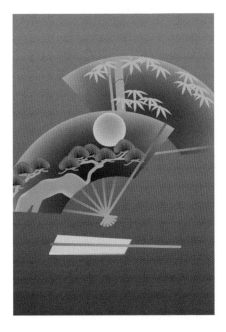

● CD 05 206 – 207

MOON-3

It goes without saying that the traditional pattern is closely associated with literature, *waka* in particular. The meanings of the *waka* verses were chosen to be subject of patterns because, much more so then than now, whether aristocrat or common folk, their significance was understood by people from all walks of life. Furthermore, despite the shortness of their phrases, within each verse was the promise of a profound allure, so that their meaning could be sufficiently imparted and taken pleasure in without the need for expository patterns.

1 A Koetsu rendition of autumn grass and the moon on colored paper
● **CD 04_206** Honami Koetsu (1558-1637) was an important artist from early Edo. This is a rendition of a twenty-some day old moon ("fukemachizuki" – the moon finally rising in the advancing night sky). In the original work, verse of Fujiwara Hideto taken from the Shinko Kinshu is superimposed on the moon.

2 The full moon rendered on the back of a copper mirror
● **CD 04_207** Though difficult to reproduce here, the delicacy of the arista crafted inside the moon and the boldly rendered elegant lines of Mount Fuji are truly magnificent.

● CD 04 208 – 211
MOON-4

Patterns containing the moon are ubiquitous among *Maki-e* lacquer works, perhaps because the inherent majesty of *Maki-e* lacquer was considered perfectly suited to its renderings. *Maki-e* moons exude a calm and stoic attraction, and when rendered as verse, their visual effect perhaps expanded upon the meaning of the verse, thrumming the heartstrings of those who observed them. Even those who encounter them today are hard-pressed to suppress sighs at the sight of their foreboding beauty.

1 The misty moon and clouds rendered in *Urushi-e* lacquer
● **CD 04_208** The delicate brush strokes beautifully render the autumnal scene with a calm eye.

2 The moon on a *Maki-e* lacquered ink stone case
● **CD 04_209** Boldly divided by the lazily curving lines of the mountain, which is contrasted against the crescent moon, this image is exquisite in its simplicity.

3 The moon and geese rendered on a *Maki-e* lacquered ink stone case
● **CD 04_210** The combination of the moon and the wild goose is a traditional motif. The Hiroshige (1979-1858) painting that was made into a stamp is well-known.

4 The moon on a *Maki-e* lacquered incense case
● **CD 04_211** Bush clover drawn within the sphere of the moon, and the Chona and carpenter's square left behind on the half-finished bridge. Perhaps this is one scene from the story of work performed under this moon.

● CD 04 212 – 215
MOON-5

1 A deer on a *Maki-e* lacquered writing table
● **CD 04_212** The image of the deer in repose beneath the moon is often made the subject of verse of diverse interpretations. The sharp low point of the moon evokes a sense of the disconsolate nature of late autumn.

2 The full moon in *Maki-e* lacquer
● **CD 04_213** The full moon shines upon the autumn grasses, rotting stakes and an arrow, rendering a dreadful moonlight reminiscent of *The Tale of the Heike*.

3 The moon and chrysanthemum rendered on a *Maki-e* lacquered tray
● **CD 04_214** This work is somewhat lacking in elegance, perhaps because of the tidy way in which the chrysanthemum and the arista are rendered facing the moon.

4 Pine, crane and moon on a black *tomesode* formal ceremonial kimono
● **CD 04_215** A pine forest imbued with sentimental hues glimmering waves and monochromatic cranes under the full moon, a stylized pattern encountered often from ages long past on *tomesode* (a prestigious and formal ceremonial kimono).

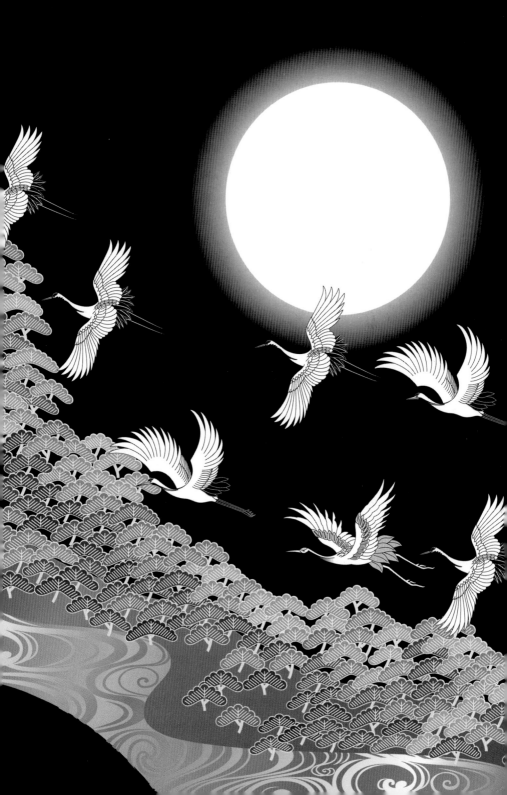

● CD 04 216 – 219
THE MOONLIT NIGHT

The light and shadow rendered in *Maki-e* and *Urushi-e* works have an intrinsically sensual effect that is reminiscent of the night or the moonlit sky. This image is undeniably one of the reasons why they are thought to exude a stately and serenely silent picturesqueness. However, even if there are few patterns that are clearly christened "the moonlit night," there are some that give the impression of the moonlit night without actually rendering the image of the moon. Aesthetic perception, of course, it left to the discretion of the observer.

1 Falling cherry blossoms of crepe silk *Yuzen* print fabric
● **CD 04_216** The flowing water against the dark background color, the glow of the falling cherry blossoms, and the white rabbits in motion express a flower banquet in progress under a moonlit night sky.

2 Distant mountains rendered in *Maki-e* lacquer
● **CD 04_217** Though mysterious, it conjures images of ominous mountain paths on moonlit nights.

3 An autumn field rendered on antique Yuzen print fabric
● **CD 04_218** A shimmering river, evening mist, autumnal grasses against a purple grey of contrasting density and cranes in silhouette – the moonlight night as autumn comes to a close.

4 Moon-lit ivy on antique *Yuzen* print fabric
● **CD 04_219** Ivy rendered to resemble vine plants (cayratia japonica, Boston Ivy and crimson glory). From the oxidized silverlike hue of the leaves one gets a sense of the glow of the moonlight.

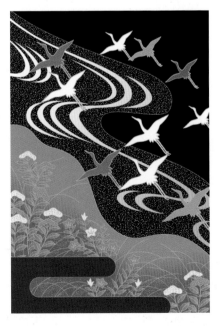

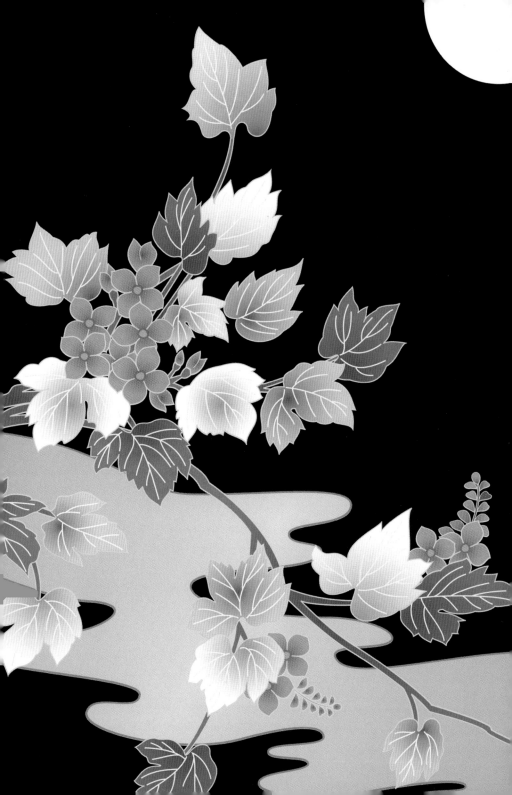

● CD 04 220 – 223
CLOUDS-1

In the world of industrial art, the pattern form has been governed by the stringent restrictions of tradition, heritage and apprenticeship, and because change does not come easily, a great deal of time is needed to perfect a given style (figurative form) of pattern. Of course, a tradition cannot be formed if the method of expression changes on a whim. Cloud patterns have a particularly long history, one old enough to be thought to have originated with the dragon pattern during the Han Dynasty in ancient China (some 2000 years ago), but while their form may have been perfected (particularly in the case of the auspicious cloud pattern), they are in some ways different to use today.

1 Auspicious cloud variation-1
● **CD 04_220** Using variations of the auspicious cloud, I have created some examples of easy-to-use contiguous patterns. This will be the basis for the evolution of subsequent patterns.

2 Auspicious cloud variation-2 Cotton
● CD 04_221

3 Auspicious cloud variation-3 Background pattern
● CD 04_222

4 Auspicious cloud variation-4 Shadow
● CD 04_223

● CD 04 224 – 227
CLOUDS-2

1 Auspicious cloud variation-5 Background pattern
● CD 04_224

2 Auspicious cloud variation-6 Background pattern
● CD 04_225

3 Auspicious cloud variation-7 Background pattern
● CD 04_226

4 Auspicious cloud variation-8 Shadow
● CD 04_227

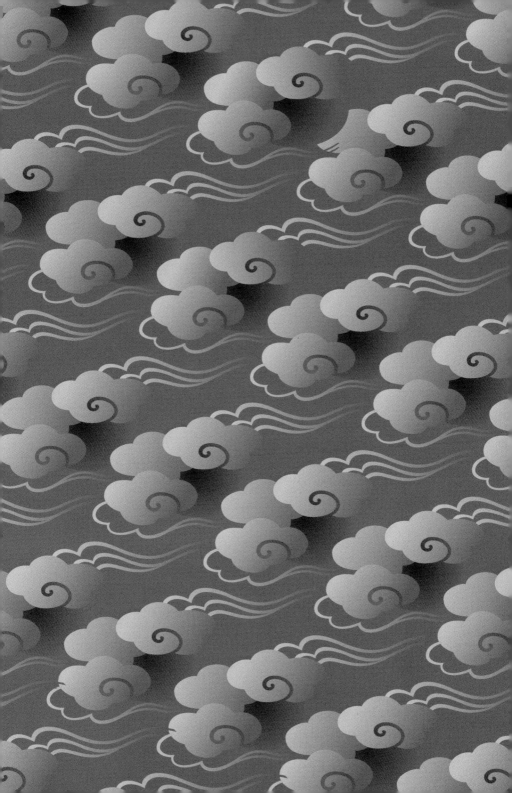

● CD 04 228 – 229
CLOUDS-3

1 *Komon* pattern of a gathering of *kumotori* clouds
● **CD 04_228** Patterns of gathered items appear in diverse compositions and combinations of *komon* that are all unique. In this way three-dimensionality is achieved and variety is added to the uniformity of the *komon* pattern.

2 A *kumotori komon* pattern of densely arrayed chrysanthemum
● **CD 04_229** Though the *kumotori* pattern is slightly difficult to recognize, this aspect makes lends a certain modesty to this rather luxurious *komon* pattern.

● CD 04 230 – 233

MIST-1

Modeled after the *katakana* character "エ" (Ko), *ko-kasumi* (literally, ko-shaped mists) can be difficult to differentiate from *Ko-gumo* (ko-shaped clouds), the name given to other similarly shaped objects rendered in pattern. But as the verse, "It is cloud or mist..." suggests, they have similar characteristics, the only difference being that clouds are more substantial than mist, so one need not be too concerned with their differences.

1 *Komon* wavering background pattern of mist and plovers
● **CD 04_230** The artist has pushed contrast to the limit in this design. The convincing symbolization is artfully done in this humorous rendition.

2 *Chumon* pattern paper decorated with mist and butterflies
● **CD 04_231** Probably Japanese bluestar and T-shaped sparrows. The simply rendered lines of the mist are reminiscent of spring mist.

3 *Chumon* pattern paper decorated with mist and peony
● **CD 04_232** The straight vertical lines artfully emphasize the random horizontally curving lines.

4 Cranes soaring in the mist
● **CD 04_233** The mist is expressed as dotted lines and groupings of dots. The use of cranes to part the mists is well done.

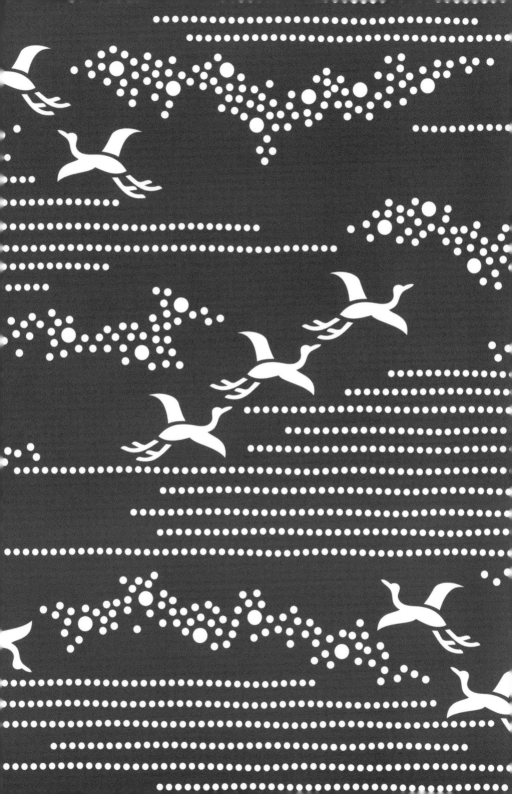

● CD 04 234 – 237
MIST-2

1 Autumn grasses rendered in *Nabeshima* undergaze
● **CD 04_234** Contrasting the autumn grasses against the bold *ko-kasumi* trimming, this layout exudes an innovativeness that gives the observer the sense that he is seeing something completely new.

2 A kitsuke undergarment decorated with cherry blossoms in a mist
● **CD 04_235** In Kabuki, *kitsuke* is an outer garment, while in Noh it is an undergarment. The embroidered lines within the *ko-kasumi* form slightly wavy stripes, creating an odiferous mist.

3 Autumn grasses and plovers on a *katabira* unlined kimono
● **CD 04_236** Though this is not called a mist pattern, the hazy flowers are clearly replete with the allure of the mist.

4 A mist pattern rendered on Kaga *Yuzen* print fabric
● **CD 04_237** This realistic expression has not lost the key point of the pattern. The mist, through which the flowers seem almost transparent, conveys a profound sensitivity.

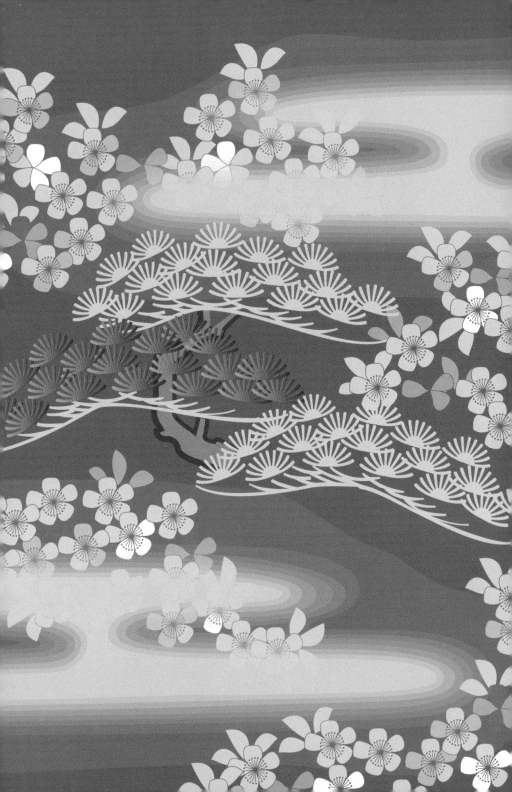

● CD 04 238 – 239

MIST-3

1 Weeping cherry blossoms and a rhombic pattern of Matsukawa mist rendered in Chinese-style brocade
● **CD 04_238** The next two items depict not the figurative form of the mist, but the mist as a proper noun. The interesting aspects of patterns with variation.

2 A *chumon* pattern of grasses and blossoms in Matsukawa mist rendered on a paper stencil
● **CD 04_239** The contrast between straight and curved lines, solid and fine lines. The artist know well how to harmonize combinations of contrastive elements.

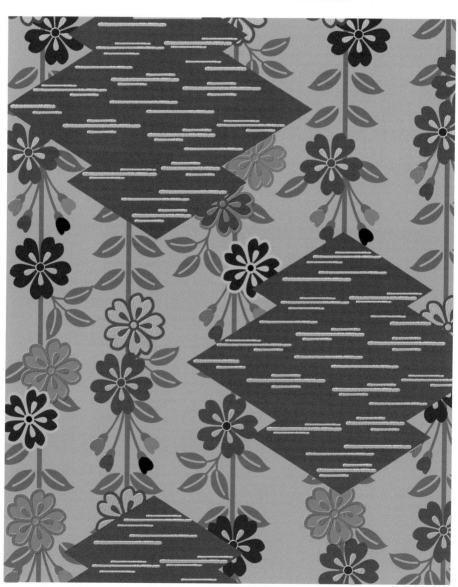

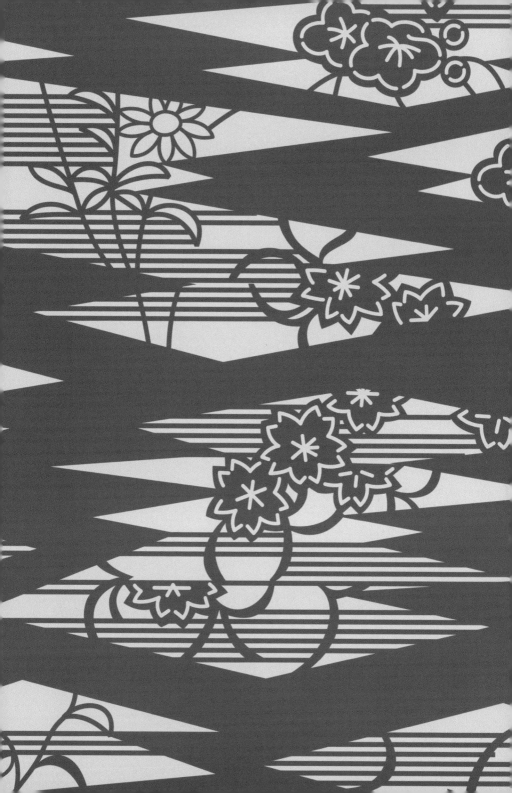

● CD 04 240 – 243

HAZE

There are no patterns entitled "haze." The dictionary defines haze as a fine fog that stands low in the atmosphere or a smoky fog. However, among the traditional patterns, it has an expression that does not fall within the group known as mist, an appearance that both obscures close places and is moist. A line must be drawn between these patterns and the ordinary landscape pattern.

1 A *chumon* ivy pattern on a paper stencil
● CD 04_240 The starkly visible vines drawn above the almost blurry hesitantly rendered vines on morning haze express a depth and the crispness of the morning in summer.

2 Autumn grasses on a *katabira* unlined kimono
● CD 04_241 Depicting the flow of air in such a way that only be haze, this design expresses the beauty of a chill field in the beginning of autumn.

3 Lilies in a pond on silk gauze sash
● CD 04_242 Silk gauze is a fabric used only during the summer. Its thinness makes it impossible to achieve clear lines even when dyed. It has an intrinsic coolness like the feeling of looking through the haze on a summer morning.

4 Bamboo and clouds on a long-sleeved kimono
● CD 04_243 Though a cloud pattern, the bamboo grove rendered using tie-dyed dots only seem to fade into the morning haze.

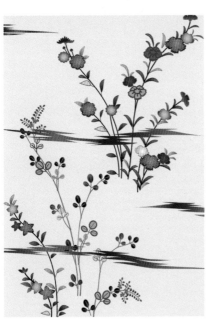

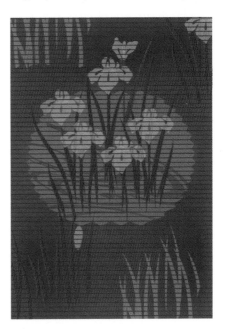

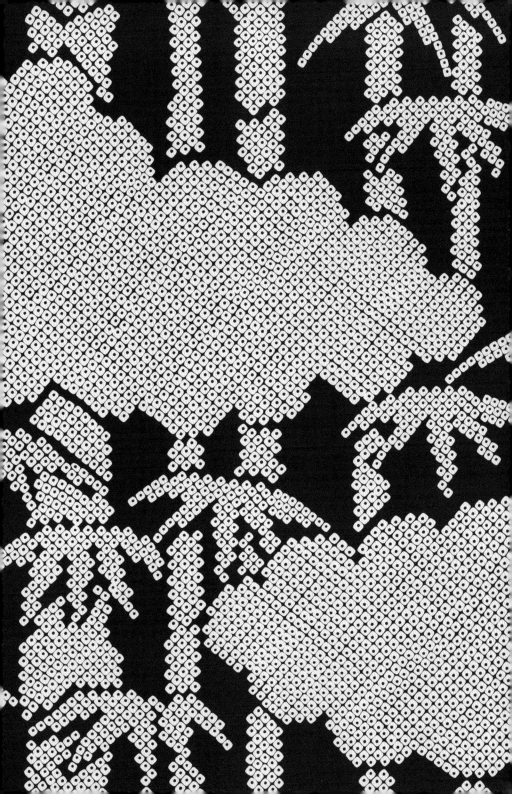

● CD 04 240 – 243
SNOW

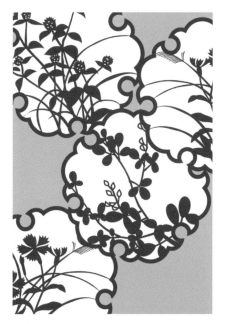

1 A *chumon* ivy pattern on a paper stencil
● **CD 04_240** The starkly visible vines drawn above the almost blurry hesitantly rendered vines on morning haze express a depth and the crispness of the morning in summer.

2 Autumn grasses on a *katabira* unlined kimono
● **CD 04_241** Depicting the flow of air in such a way that only be haze, this design expresses the beauty of a chill field in the beginning of autumn.

3 Lilies in a pond on silk gauze sash
● **CD 04_242** Silk gauze is a fabric used only during the summer. Its thinness makes it impossible to achieve clear lines even when dyed. It has an intrinsic coolness like the feeling of looking through the haze on a summer morning.

4 Bamboo and clouds on a long-sleeved kimono
● **CD 04_243** Though a cloud pattern, the bamboo grove rendered using tie-dyed dots only seem to fade into the morning haze.

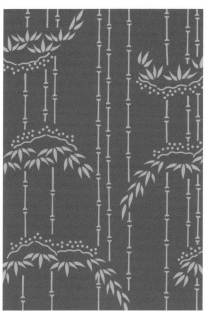

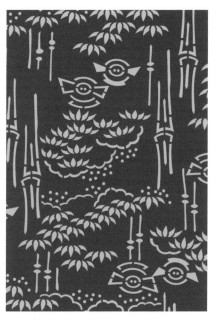

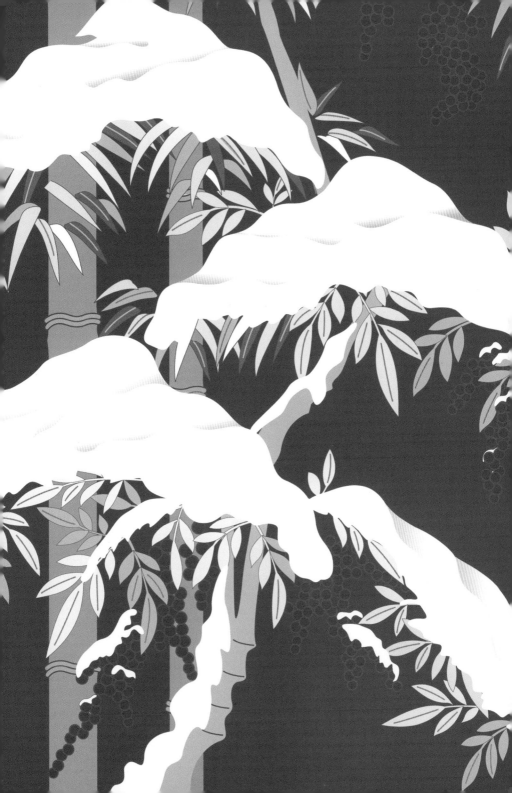

● CD 04 248 – 250

AIR

While thoughts of the flowing of the air do not normally surface to the conscious mind, something will often make us aware of a particular, theretofore ignored, volume of air. We should be grateful to our forefathers who gave a name to this nebulous phenomenon, rendering it in form and fixing it firmly in tradition.

1 A *chumon* pattern of wisteria blossom circles and undulating vertical lines on a paper stencil
● **CD 04_248** The vertically undulating *tatewaku* pattern is a masterpiece rendition of a curved lined pattern of air turbulence. As long as the figurative form is observed, this *tatewaku* pattern could go on for infinity.

2 Dew-covered grass on embroidered foil-cloth
● **CD 04_249** Grass laden with snow circle patterns is integrated with dew-covered grass suggesting the presence of cold air.

3 Lightning bolts and peony on a *Maki-e* lacquered basin
● **CD 04_250** There are numerous evolutions of the zigzagging form of the lightning bolt, which is sometimes rendered in combination with the squared swirls of the thunder pattern.

The Attached CD-ROM: Using the Material Provided

The purchaser of this book is permitted unrestricted use of the data recorded on the accompanying CD-ROM, either in its original form or in a modified fashion.

Credit or other such acknowledgment need not be noted in the event of such use. The data provided may also be used overseas, as use is not regionally restricted. Furthermore, copyright fees or secondary user fees are not required to use this material.

Adobe and Adobe Photoshop are either registered trademarks or trademarks of Adobe Systems, Incorporated registered in the United States and/or other countries. Microsoft, Windows, and Windows

XP are either registered trademarks or trademarks of Microsoft Corporation registered in the United States and other countries. Apple, Macintosh, Mac and Mac OS are either registered trademarks or trademarks of Apple Computer, Inc., registered in the United States and other countries.

All other brand and product names and registered and unregistered trademarks are the property of their respective owners.

About the Author

Shigeki Nakamura An art director since 1964, he established Cobble Collaboration Co. Ltd. in 1987. The company published a book of ESP Pattern Library Digital Materials, which can be seen on its website (cobbleart.com). He has received many awards, such as the Minister of International Trade and Industry Award, and he is a member of the JAGDA (Japanese Graphic Designer Association).